Pictures are worthwhile for remembering something. It's the most important thing about the pictures—to remember something about the past, but not the horrible past, the nice past—nice things you once had. I keep my pictures in an album in my mother's drawer. I look at them sometimes, but not always. When there's nothing I'm doing, I try to remember how it was when I took the picture. I just think of the thing rewinding and going back like a cassette rewinding all those things over again.

PALESA MOHOLOE, SOWETO

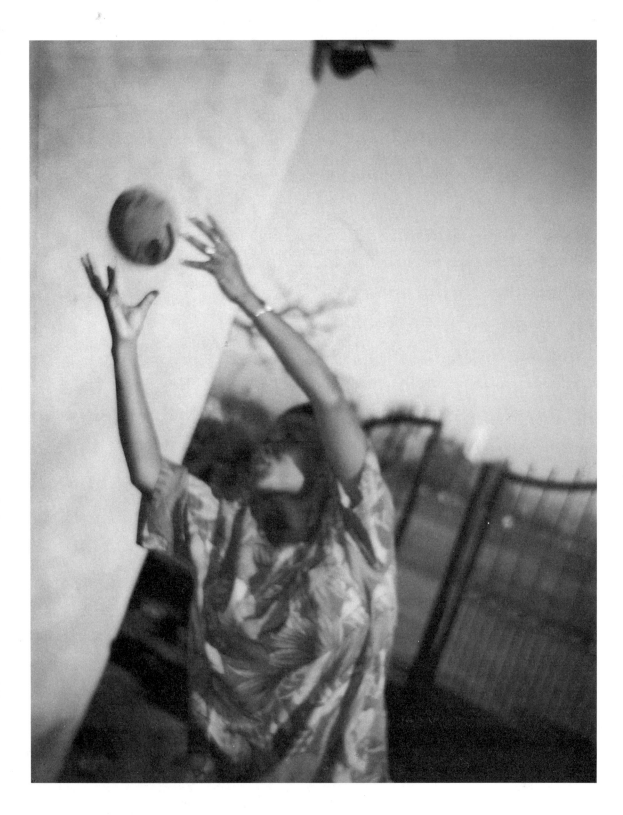

Wendy Ewald

I Wanna Take Me a Picture

Teaching Photography
and Writing
to Children

Coauthored by Alexandra Lightfoot

A LYNDHURST BOOK published by the Center for Documentary Studies

in association with

BEACON PRESS Boston

Beacon Press
25 Beacon Street
Boston, Massachusetts
02108-2892

Beacon Press Books are published under the auspices of the Unitarian Universalist Association of Congregations.

Text design by Katy Homans

cover: Harshad, Hasmukh, Chandrakant, and Dasruth learning to hold the camera
WENDY EWALD

page 2: My mother catching the ball
PALESA MOLOHLOE

09 08 07 5 4

Library of Congress Cataloging-in-Publication Data
Ewald, Wendy.
 I wanna take me a picture : teaching photography and writing to children
/ Wendy Ewald, Alexandra Lightfoot.
 p. cm.
 Includes bibliographical references.
 ISBN 0-8070-3140-2 (hc.)
 ISBN 0-8070-3141-0 (pbk.)
 1. Photography-Study and teaching (Elementary) 2. English
language-Composition and exercises-Study and teaching (Elementary) I. Lightfoot, Alexandra.
 II. Title.
 TR161.E93 2001
 372.67'2-dc21 2001003907

Lyndhurst Books publish works of creative exploration by writers and photographers who convey new ways of seeing and understanding human experience in all its diversity— books that tell stories, challenge our assumptions, awaken our social conscience, and connect life, learning, and art. These publications have been made possible by the generous support of the Lyndhurst Foundation.

Center for Documentary Studies at Duke University
1317 West Pettigrew Street
Durham, North Carolina 27705
http://www.duke.edu/cds

Contents

7 Introduction

17 Learning to Read Photographs

29 Literacy through Photography

79 Getting Technical

119 Using Photography in the Classroom

145 Using Photography in Communities

165 Resources and Readings

174 Acknowledgments

Introduction

We hear it all the time: we're living in a visual culture. Nearly every day we're warned about the bad effects on children of much of what they see. Little or no thought, though, is directed to the benefits of positive visual stimulation. After children grow beyond infancy, we don't pay much attention to creating exciting visual environments for them, and once their nursery school days are over, we stop engaging with them in visual play.

Some attempts are made in our elementary schools. Hallways are filled with children's artwork; lesson plans are translated on to poster boards with striking images, important words singled out for attention. Not so long ago, state and national mandates defined visual literacy as one of four forms of literacy (reading, writing, and listening were the other three). Yet most teachers and administrators are not at all sure what "visual literacy" means. If they do have some notion about it, it's usually limited to decoding commercial messages.

Even very young children, when encouraged, have the ability to express their complex emotional lives visually. When my son Michael was tested to determine whether he should be placed in pre-kindergarten or kindergarten, he was asked to make drawings to ascertain his level of intellectual and emotional development. Despite our protests, he was placed in kindergarten (rather than pre-kindergarten) because when asked to make a drawing of a man, he included his heart and soul.

In her wonderful book *The Art of Teaching Writing*, Lucy Calkins discusses the stages of a child's development as a writer. She points out that until the second or third grade a child's predominant means of self-expression is drawing. She adds, "Not only the act of drawing but also the picture itself can provide a supportive framework for young writers." In time, Calkins continues, children learn to write detailed stories without illustrations. But when they're just beginning to write, they often rely on their drawings rather than their writing to convey the meaning of the story.

In any case, once students do begin to write, very little attention is paid to their visual skills. I'm forever noticing how classrooms are set up—how the furniture is arranged, what's on the wall, how it's displayed. It's disconcerting to come up against a lack of sensitivity about what our visual surroundings communicate to people, and how they are affected by it.

Samju looking at her negatives
WENDY EWALD

7

This came home to me recently when I accompanied my son to his kindergarten orientation. Outside each classroom (there are ten kindergartens in Michael's large public school), the teachers had mounted cut-outs of various things—apples, stars, or animals—with the name of each child written inside the cut-outs so the new kindergartners could find their rooms. Each class had a unique symbol. My son's was an owl. But the owl decorations identifying his classroom were dark brown. The names of the children, written in black on these dark backgrounds, were very difficult to read, especially for five-year-olds just learning to pick out the letters of their names. Inside the classroom, the teacher had taken the time to affix small owls, again with the students' names written on them, above each of their lockers. But the owls were placed toward the top of the lockers, high above the students' heads, and virtually impossible for someone of kindergarten height to read. To little children already versed in our culture's visual rhetoric, this well-intentioned effort must have seemed incoherent and graphically illiterate.

This book describes an approach to teaching photography to children. It grew out of an attempt to address what I saw as the need to attend to our neglected physical and visual surroundings, and the need we all feel to articulate and communicate something relevant about our personal and communal lives. *I Wanna Take Me a Picture* evolved gradually from thirty years of working with children between the ages of eight and thirteen, years of thinking about how we learn, and how we express ourselves with images.

In 1970, the summer I was eighteen, I had a job working with children on an Indian reservation in Labrador. I was very excited about photography. I'd been photographing my brothers and sisters with a 4 x 5 Crown Graphic, a vintage press camera, the kind that calls for pulling a black cloth over your head to block out the ambient light so you can see the image on the ground glass. In Labrador I taught children with more simple cameras. The Polaroid Foundation had just started giving out cameras and film to teachers who were working with what were then called "underprivileged" children. I submitted an application; Polaroid gave me ten cameras and one hundred film packs to take to Canada. In working on the reservation, I discovered that when I demonstrated how the camera worked to the people I wanted to photograph, everyone, myself included, felt more at ease.

Since then, I've worked with children in places all over the world—among them an Italian neighborhood in Boston, the Colombian Andes, rural India, the Appalachian mountains, and North Carolina, where one of my students was fond of saying, "I wanna take me a picture." I've heard it said by children and adults many times, in many languages—"I want to take a picture"—when what they meant was, "I want to be photographed." Their desire to be photographed was as strong as their desire to photograph.

My first summer in Labrador, I held a photography class in the afternoon for any child who wanted to come. Each child took a camera and pack of film. A group of about fifteen of us walked around the reservation. I took pictures of my students and their families (when they'd allow it) and other children. I was selective and cautious. The children, however, took pictures of everything they saw: the chief, drunk, trying to saw a board; young couples fighting; a teapot on the windowsill; a great-aunt in her white Sunday dress sitting on the rocks overlooking the sea. The children's pictures were more complicated and disturbing than mine—and, I began to realize, much closer to what it felt like to be there.

One afternoon, a fourteen-year-old boy named Merton Ward and I decided to photograph the cemetery together. Merton split his time between the reservation and South Boston, where his mother lived. He said he'd been deported from the United States for breaking parking meters, so he had to use a false name when he crossed the border. He knew more about the outside world than others on the reservation. Perhaps because I was familiar with that world, too, Merton and I became friends.

He had his Polaroid Sharp Shooter; I had my Crown Graphic. We casually began by photographing the whole graveyard, then moved in closer to take a picture of Merton's grandmother's grave. I went first. I centered the white tombstone, shooting it slightly from above so the stone was framed by the grass. In the background, on either side of the stone, were white crosses. Merton squatted down and took his pictures from below. He placed the stone to the right so it veered out of the picture plane. His tombstone looms over the viewer and seems even more menacing because it looks as if it's going to take off.

My photograph shows what an Indian graveyard looks like. You can read the inscription on the gravestone and see the simple handmade crosses. Merton's picture is grainy, washed out, and the proportions are inaccurate, but his cemetery is a frightening place. No one visits it or places flowers on

Black River
BENEDICT MICHELLE

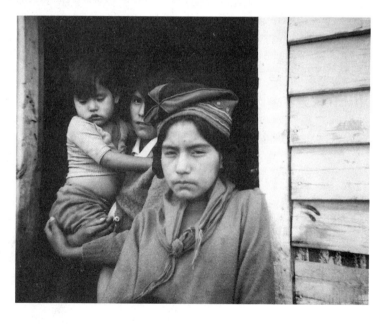

the graves. Sometimes people see ghosts there. Merton's photograph reflects that fear.

Now, when I look at the pictures we took, my photograph reminds me of the magic I associated with that neat little graveyard and the rugged beauty of the reservation; Merton's photograph makes me think of the young men I knew who died violent deaths during the summers I was there, how once Merton had to guide me toward a coffin, and how frightened I was to look into the young man's face.

I arrived in Labrador three years before the uprising at Wounded Knee, which would focus America's attention on Native rights. The reservation was already in crisis, its young people caught between two cultures and two languages. Their parents were mostly unemployed. The nomadic hunting life that had sustained them for centuries was coming to an end, and nothing had come along to replace it. Permanent housing was inadequate for the arctic climate; alcoholism was endemic.

It was clear that some of the older children were very worried about the future of their people. I asked them if they'd like to create a story about the place they lived. If they wanted, they could use images as well as words. They went off with the cameras and came back the next day with their work. Their pictures and writings made for an uncompromising look at the problems they faced. Kathy Louis, a ten-year-old, wrote:

> I like to take pictures because it is fun to take or keep for a long time. It also can let you remember where, who, and what it is like. I took these pictures because I know what I feel about them and I feel so bad because most of the people who work at the sawmill are not paid as the people over across the river. Some people have to walk all the way down the hill just to get some water, the pump houses they made are not good. The garbage is not sent away to another place where there is nobody instead of lying on the ground. At the school only grade IX course is being done there. If grade XI was being done there it would be much better. The garden there in the picture is a potato garden which is not very good. It is used for the people who don't have enough money to buy potatoes in the store.
>
> BENEDICT MICHELLE

> Indians belong to nature and we know more about the land than white people do. But I'd feel finer about being an Indian if only we had better houses, if we had better schools, high schools, colleges, and training schools so we'd be more skillful and educated. Then Indians wouldn't have to live on welfare. They could have jobs and earn their own money.

It's unlikely that the young people would ever have written what they did without pictures to prompt them (Kathy's writing came from beautiful landscape photographs she'd made), and the pictures would have been difficult

to decipher without the stories to accompany them. Benedict Michelle photographed some of the problems on the reservation, like the sawmill, which represented low-paying jobs; garbage strewn on the ground; a barren garden. His text began, "I took these pictures because I know what I feel about them and I feel so bad . . ."

The children's pictures and words were hardly adequate to convey the difficulty of their situation, but their photo-essays were a starting point for acknowledging and discussing, in their own voices, a very tough predicament. (One of the obstacles to grasping the scope of the problems on the reservation was that the children's worldview was steeped in internalized racism. When I took a group of them to see a Western at the only movie theater in the area, they cheered for the white settlers when an Indian was shot.)

I went on to teach photography to children in more structured situations. I began to experiment, in conventional classrooms, with how photography and writing stimulated one another. Many of the students I worked with had trouble writing; they would labor painfully over a sentence or two. But when they worked from a photograph that had something to do with their own lives, especially a picture they had taken themselves, they were able to write more—and what they wrote about was their own experiences. After years of experimenting with this method, I was invited by the Center for Documentary Studies to start a program in the Durham public school system in North Carolina called Literacy through Photography.

I found that it was necessary to explain to my students that making an interesting photograph called for more than just pointing the camera and shooting. Asking them to write about the subject they were going to photograph, then asking them to make a list of images suggested by their writing—this was a way to help them organize their picture-taking before they went out to shoot. Having gone through some elementary step-by-step planning, they were less likely to be overwhelmed by all the possibilities open to them once they had the camera in their hands.

As the classrooms I worked in became more and more diverse, I realized that photographs provided a much-needed opportunity for the students to bring their home lives into school.

One of the classes I worked with in Texas was typical of the rapidly changing demographics in American schools. It included students from

Latin America and Vietnam, as well as white and African American Texans. These children had never seen each others' neighborhoods, certainly not each others' homes or families. They were essentially strangers to each other. A fifth-grade African-American boy told me that he thought the Vietnamese children's years were "different"—if a girl was twelve in Vietnam, she would be ten in Texas. When the students brought back pictures of their families and communities, each child tried to explain what was going on in the pictures, and the others eagerly asked questions.

These days, teachers rarely come from the same community as their students. Photographs can give them a glimpse into their students' lives. I once taught in a summer school program for children of migrant workers in eastern North Carolina. The families traveled from Central America or from the Florida sugarcane fields. In North Carolina they lived in migrant camps, tucked away, often hidden from view. The fourth-grade teacher I worked with had never seen a migrant camp, and was grateful to be able to look at the children's pictures. She was astonished by the primitive conditions they lived in, so close to her own middle-class community, and she was able to better empathize with their struggle to negotiate the Anglo world.

The LTP program in the Durham public school system quickly grew to include more and more schools. Before long it became impossible for me to teach in all the classrooms that wanted a photography and writing program. In 1991 I began teaching a course called Literacy through Photography for undergraduate and graduate students at Duke University. The course touched on many different areas: They studied photography, the history of the school system, the sociology of the Durham community, current ideas about teaching. The main element of the coursework was hands-on teaching of photography and writing in one of the Durham elementary school classrooms. Organizing this course gave me a chance to articulate a process of teaching intuitively acquired over many years.

At the end of the course, the university students helped the elementary school children create an exhibition. Each child used a piece of poster board to make a collage of his or her photographs and writings. The students had been encouraged to express themselves freely and openly, and their posters reflected that frankness. Some pictures and stories alluded to drug dealing in their neighborhood or run-ins with a mother's boyfriend.

There was a marked difference between the openness and enthusiasm of the teachers in their classrooms and the kind of reception the work

received in public exhibition at the schools. Six out of seven exhibitions were censored. Many of the teachers and their administrators felt that the content, and sometimes the presentation, of the children's work wasn't suitable for display. Indeed, the work wasn't your everyday "children's art." It didn't look like the other art cheerily decorating the fluorescent-lit halls. This work had an unsettling energy. A lot of it wasn't very neat, and much of it was about life outside the school.

The kids' work was clearly something more than cute mimicry of grown-up, mass-media imagery. If my students were to continue to have opportunities to express themselves in their classrooms, I realized I would have to work more closely with their teachers. I realized, too, that teachers need the kind of support and encouragement LTP could bring, as well as the opportunity to develop their own creative abilities.

Photography is perhaps the most democratic visual art of our time. For most of us, picture taking is part of our family lives. We don't need a particular talent, like the hand-eye coordination necessary for drawing, to render what we look at. Even children and adults unfamiliar with photography can make photographs of what they see and imagine. For those of us who have used cameras, photography offers a language that can draw on the imagination in a way we may never have thought possible before.

I began offering summer workshops in the teaching of photography and writing for the Durham teachers themselves. Eventually we began to get requests from artists, teachers, and community workers around the country who wanted to start similar programs of their own. Alexandra Lightfoot, who was then a Ph.D. candidate at the Harvard School of Education, was teaching the LTP course with me. Based on our discussions with people in the courses and workshops, we learned it would be helpful to write a book about our experiences working with children, a book that could also serve as a reference for creating writing and photography programs. We also thought that such a book could be important for families who would like to encourage their children to go beyond making the ordinary snapshots of family life.

We have divided the book into chapters that follow the process we use in the classroom, starting with a chapter about learning to read photographs. The second chapter outlines the way in which concepts of photography and writing are combined, and the assignments the children carry out to

broaden their notion of documenting their lives. These assignments start with self-portraits and move onto family, community, stories, and dreams or fantasies. In the third chapter we describe how the photographic process can be taught simply, with a minimum of expense. The final two chapters look at how an LTP project can be integrated into a school curriculum and how it might function in a community or family setting. We hope that *I Wanna Take Me a Picture* provokes thought and provides the tools for Literacy through Photography projects in both schools and homes.

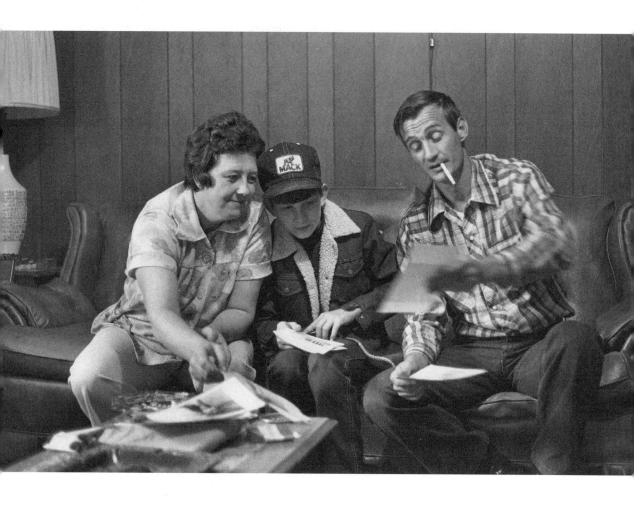

Learning to Read Photographs

Photographs hold an honored place in most homes. In family albums, on mantels, tables, and walls, they serve as fond reminders of distant relatives and friends and times gone by. Snapshots comprise our private and semi-public history. Fascinating as they may be, however, they are seldom illuminating to anyone other than family and close friends. Most of my students begin with the idea that an object or person in a photograph embodies, and therefore projects, an emotion particular to that object or person. They might attribute happiness, for example, to a picture of their favorite uncle, regardless of his pose or the background he's set against.

The most difficult part of teaching photography to children is helping them understand that simply making a visual record of something does not necessarily confirm its worth. Snapping a picture of Uncle Frank doesn't automatically convey the richness of the photographer's feelings for Uncle Frank. The fundamental lesson is this: an object of desire is transformed by the photographer's eye and sensibility in the making of the photograph. A central goal of my program is to guide my students toward an understanding that photographs reveal as much by the way a subject is photographed as by what is in them—that photographs communicate first visually, then emotionally.

I've found that before teaching children how to take photographs, it's helpful to spend some time with the children looking at images and talking about them. The younger kids tend to be more imaginative and free-flowing in their responses. What children gain through this process is not so much "visual literacy" in terms of learning how to decode the commercially illustrated world; instead they learn to look closely at visual images and think more consciously about what they see, about the various elements that go into making a photograph, about how images can communicate an idea. What is important is not just the picture's embrace of a subject but the way in which the picture is made and its capacity to evoke a particular feeling.

The first thing I discuss is the difference between various types of photographs, including advertising photographs, documentary photographs, and snapshots. Advertising photographs are used to incite a certain response in the viewer. Photographs taken by an experienced or professional photographer offer a definite point of view. If successful, they also permit viewers

Delbert Shepherd and his parents looking at family photographs
WENDY EWALD

The Shepherd family
album
WENDY EWALD

to bring their own sensibilities and experiences to the images. In examining these kinds of photographs with children, I try to focus their gaze and guide their inquiry, while leaving room for a range of responses.

Because photographs are so specific, they are especially useful for stimulating conversations with children. I ask my students to "read" images by examining the details of a photograph and describing what they see. These discussions tap into what the children can see and know, as expressed in images—which in turn serves as a springboard for their storytelling and writing. (This process also serves, naturally, as preparation for making their own photographs.)

We often start by looking at a photograph from Helen Levitt's book *A Way of Seeing*. I ask the students to list all the things they see in the picture, a lively street scene with children of different races playing with a large wooden mirror frame. The image is richly detailed and full of interesting story possibilities. I ask the children to look closely at the photograph and record what they see by listing as many of the physical objects as they can. Frame . . . Coca-Cola sign . . . boy with torn shirt . . . It becomes a kind of contest to see who can list the most things. Even after years of looking at this image, my students show me things I haven't seen before: the older

From *A Way of Seeing*
HELEN LEVITT

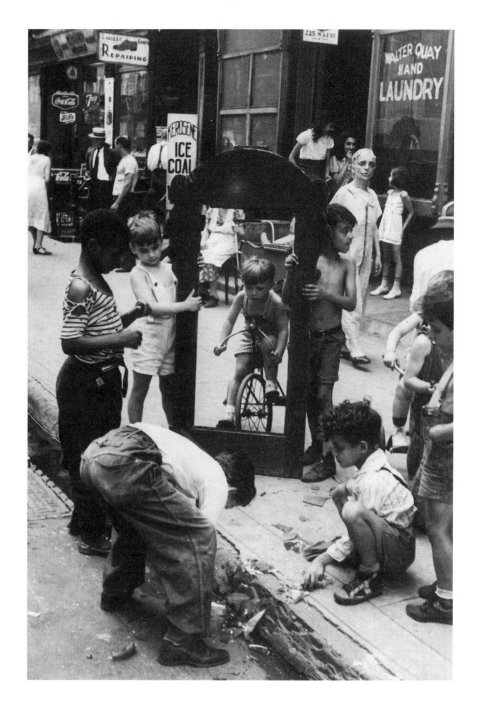

woman passing the boys holding the frame—look how her sunglasses are casting shadows on her eyes!

The children and I ask each other questions about the details they have identified. The key question for the story of Helen Levitt's photograph is, of course, where did that frame come from? One of the students points out bits of debris in the gutter, providing us with an important clue. What is it that the children in the foreground are playing with—trash, shards of glass?

Eventually we arrive at a consensus: the debris is pieces of a mirror. But whose mirror, and how did it come to be broken? What is happening outside of the frame of the photograph? This may lead us to a discussion about who the people in the street are. They don't seem to be paying attention to the boys. What does that tell us about this community?

One of the students usually points to the boy in the street, the one wearing the torn shirt. I ask how the people in the photograph are different from one another. How do we know they're different from the details we've observed?

We turn our attention to the geographical and historical setting of the picture. To get us going in this direction, I may point out the sign advertising kerosene, ice, and coal. Where was the picture taken? When? Have things changed since then?

We begin to discuss our interpretations of the photographer's intentions. Who is the photographer? Is she or he an insider? An outsider? How do we know? In order to bring this highly speculative discussion back to earth, I ask, where is the camera? Where are the subjects looking?

In the case of Helen Levitt, these are trick questions. Sometimes Levitt used an angled viewfinder, an innovative tool for the time. When, for instance, her camera was pointed to the right, she might actually have been taking a picture of what was in front of her. This bit of inside information often leads to interesting discussions of photographic ethics. Was Helen Levitt right to make pictures without her subjects' knowledge? Was there another way for her to capture such moments of ease in her subjects? Did people think differently then about being photographed?

Whatever strategies Levitt used, the important question for us when looking at her photographs is: what is she trying to communicate about this community? The lady seated behind the frame, the man with the straw hat conversing with another man under the shoe repair sign, the boy on the tricycle—how do these clues help us answer this essential question? As the

details are identified and shared, a story begins to take shape, collaboratively told by us and the photographer. The children consider what might be happening beyond the frame of the camera lens, what relationships the individuals in the photograph share.

Reading the photograph helps students progress from observing the details of an image to trying to understand the story behind it. In reading this way, we've laid the groundwork for the children's more nuanced examination of other images, and for their thoughtful planning of their own photographs. Through the process of reading photographs, children can begin to understand that photographs do indeed convey the emotions of their subjects—not simply because of some magic inherent in the subject itself, but through the choices the photographer makes and the way in which the images are made.

Since pictures of people are usually the students' primary interest, you may want to begin by looking at portraits. Ask your students what they think a portrait is; some of them think it has to be a painting or an image of just one person. You can point out, using a series of photographs, that a portrait, however many people it may contain, is usually any image that principally describes the subject or subjects through expression, gesture, clothing, and background.

The first two portraits I usually start with are by Milton Rogovin. Rogovin spent thirty years shooting the same group of people in his diverse Buffalo neighborhood. His portraits are remarkable for their clarity. He had a knack, exceptional for a documentarian, for including only those elements that contribute directly to describing his subjects.

The pictures we look at are of the same person, an African American woman in her twenties or thirties. The setting of the first portrait is her workplace, which seems to be a factory. The camera angle is low, giving her a heroic stature. I ask the students to think about what the picture tells them about this woman by examining the camera angle, the background, the woman's expression, her pose and gesture. Some say it must be hot in the factory because of the sleeveless blouse she's wearing. And the work must be hard because she's wearing gloves.

I ask the students how each of these details contributes to their overall impression of the portrait. What do they think about this woman? Her relationship to her work? It is interesting to see how different groups of students interpret the woman's state of mind. Many read her expression

Sheryl Stevens (right) and home—with child
MILTON ROGOVIN

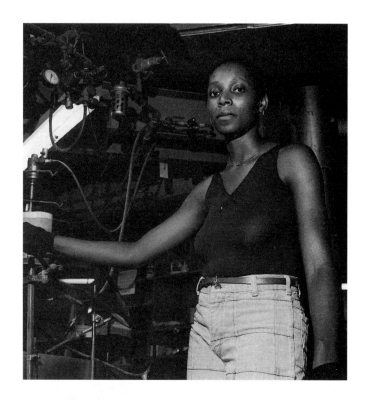

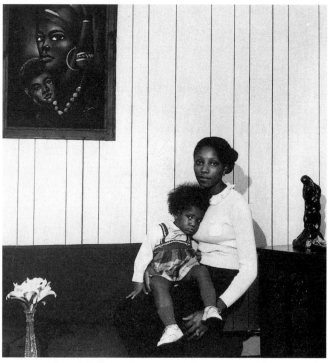

as tired or sad. Others, particularly African American students, see her as strong, and proud of her work.

Rogovin shot the second portrait at the woman's home. She is seated in the living room holding her baby daughter. A picture of an African American madonna with child is on the white wall behind her. Rogovin has shot this picture at her eye level (as opposed to the heroic low angle used in the first portrait). She appears much softer than in the first picture, so much so that it takes some students a while to realize it's the same person.

I ask them to observe the image and consider the camera angle; the background of the photograph, its composition, its contrast between dark and light; the facial expressions of the woman and her daughter. Sometimes, in order to highlight the main elements of the photograph, I ask the students to make a drawing of the composition, which is clearly divided into dark and light. The white flowers, for example, are in front of the black couch; the faces of the woman and her daughter are set off by the white wall behind them.

We continue to discuss the feeling the photographer captures here, and the relationship between mother and daughter. One of the most intriguing readings of this portrait came from a fifth-grader in Durham. She said the photograph was "about holding." She'd noticed that just as the mother sat holding her daughter, the mother in the picture above her was holding her child. And the vase in the foreground held white flowers, while the console in the background held a sculpture.

Finally, we compare this second portrait with the first one, noting the way in which the photographer has made each portrait, and the different feelings they evoke.

In photographs taken by artists or by the children with whom I work, the intention of the photographer may be less clear than in the work of a controlled documentarian like Rogovin. Still, they provide ample clues for free exploration of the images.

I'll ask my students, for another example, to look at a self-portrait titled "A still life with a picture of me" by Kelly Mitchell, one of my students in Durham. Kelly made his self-portrait by photographing his desk and book-case, which is full of encyclopedias and topped with photographs of him and his twin sister. On the wall behind the desk and bookcase is a fan, and tucked in the fan is a wallet-sized copy of the photograph of Kelly that sits atop the bookcase. There's also a mirror on the wall; in the mirror we can see reflections of the fan and the desk.

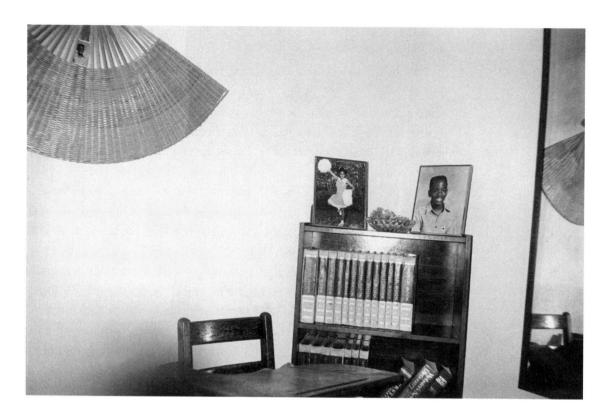

A still life with a picture
of me
KELLY MITCHELL

After the students have spent a few moments looking at this photo-
graph, I ask them if they can guess who the subject of the self-portrait is.
Some children are stumped by this challenge. You can guide them toward
figuring it out by encouraging them, as always, to look closely at the clues
provided by the photographer. How is the picture framed? How does the
white background complement the composition of the photograph? What
is the center of the photograph? What does this photographer want us to
know about him or her? Why does the photographer choose this particular
way to make the self-portrait?

Inevitably, there are lively discussions about this image. Many students
surmise that there is a close relationship between Kelly and the girl in the
picture. And when they spot the second, smaller photograph of Kelly tucked
into the fan, they're able to point him out as the photographer. The discus-
sion helps to open the students' imaginations to ways they can portray
themselves and others in images.

An image taken by another Durham student, Lateisha Harris, is useful
for exploring how photographs can communicate a sense of family. Lateisha

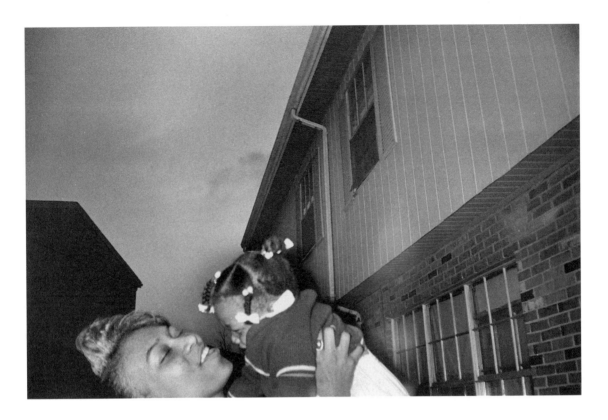

My cousin playing with
her baby
LATEISHA TENIL HARRIS

photographed her cousin outside at dusk. Her cousin holds her baby above
her upturned, smiling face.

Lateisha chose to photograph her cousin and the baby from the side
and slightly from below. But the truly remarkable thing about her composi-
tion is the way she cropped her cousin's body out of the picture. We see only
the pair's smiling faces, and the sky and buildings above them. The love
and the pleasure they take in each other seems to be making them levitate.

Once more, you can ask your students a series of questions to think
about how and what the photographer communicates. The first question is:
what do they think of this family? I encourage them to think about where
the camera must have been placed in order to make this image, and to con-
sider how this placement of the camera affects their sense of this family.
What reasons did Lateisha have for cropping out everything but the woman
and the baby, and what affect does this have on our reading of the photo-
graph? Ask them to think about the moment she chose to snap the shutter:
What does that choice tell us? What of her use of flash? How does that add
to the mood of the photograph? (Questions of this sort are keys to visual

literacy and, in my experience, are relatively simple to formulate when you join your young students in the process of looking carefully at images.)

In learning to read photographs about community, another powerful image is of the Eid feast, a Muslim holy day marking the end of Ramadan. A young student of mine named Maryam Nubee photographed this event in a Durham city park. She made a vertical photograph from some distance away. She chose to take her picture when the women, with their long white dresses and covered heads, were praying with their backs to the camera. To their left are grills for barbecuing the shanks of freshly killed sheep. In the background are the lights and chain-link fence surrounding a baseball field. The most striking element in the photograph is the large shadow of a tree in the foreground.

This can be a confusing picture to people unfamiliar with Islam. For this very reason it provides a good basis for exploring what we can know about a community from an image or series of images. In examining the image, there are the customary questions: Where is the camera situated and how does the placement of the camera affect our understanding of the community? You can also discuss where the center of the photograph is, what comprises the foreground and the background, and try to discern how different elements of the photograph (the shadow of the tree, for example) contribute to our awareness of the gathered people. At first many of the students see only a group of people in a park, but when they notice the clothing and the posture of the women they guess that some sort of ritual is taking place. Following up on this observation, I encourage them to think about what the composition of the photograph says about this group's position in the community. Why did Maryam take her photograph from a distance and include such a looming shadow? Did she, as a Muslim girl, feel that this sacred gathering should be kept secret, or did she herself feel removed from it?

When looking for photographs for your students to discuss, I'd suggest concentrating on images that are relevant to the students' lives. They might be taken from magazines, newspapers, or photography books, but avoid advertising illustrations and photographs that are too glamorous or idealized. You can also gather useful material from family albums and photographs taken by the children themselves.

Praying at Eid Feast

MARYAM NUBEE

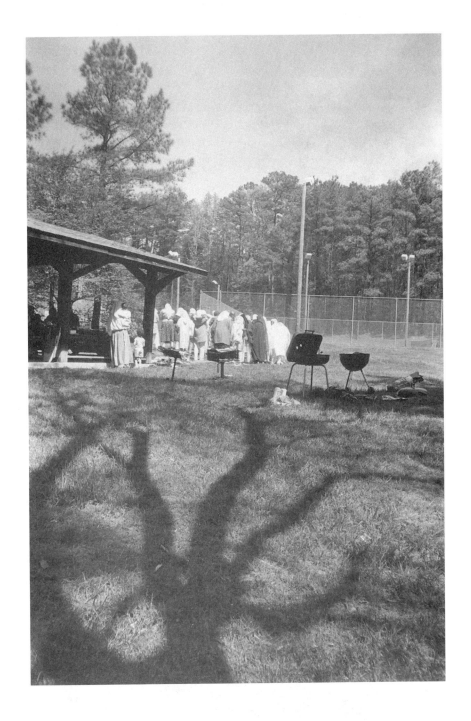

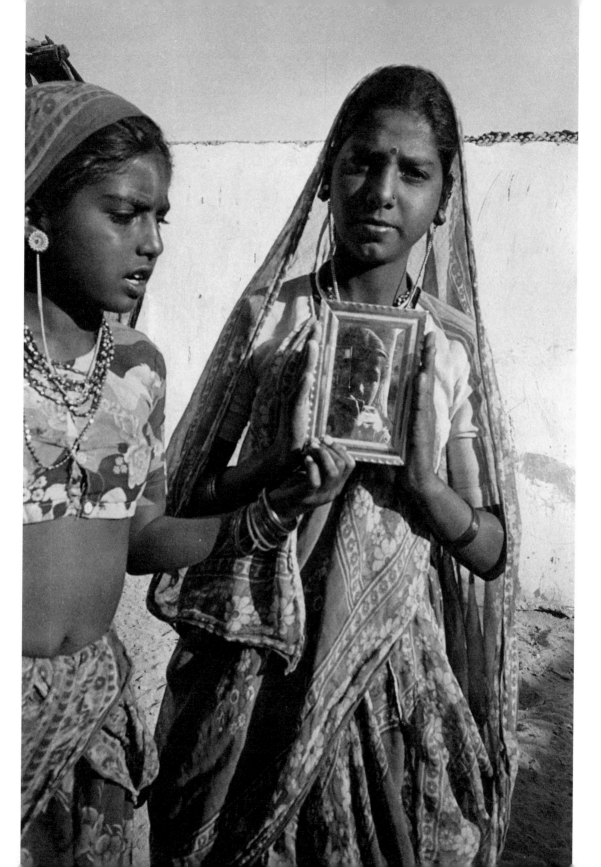

Literacy through Photography

In our family lives, photographs are generally used as a means of bestowing respect or marking a special occasion. We reserve precious film for our child's birthday party or graduation ceremony. We have little experience with photographing ordinary events in our daily lives. My students have a difficult time even conceiving of such casual pictures.

This is especially true in cultures where photographs are uncommon. When I began working in Vichya, a rural village in India, the children had few ideas about what they wanted to photograph. They certainly didn't feel that their own lives were worthy of memorializing with pictures. When pressed, they'd say that if they ever went to the city, sometime in the nebulous future, there might be an image worth bringing back. What is true for these children in rural India is true for almost all children, no matter where they live, when I first give them a camera and ask them to explore their lives.

In order to expand the children's notion of photography, I give them assignments that are relevant to their lives, starting with what they know intimately—their own selves and their families; then outward, to their community; and from there to a more freewheeling concept, their dreams. I also urge them to write about themselves, their families, and their fantasies either before or after making their pictures.

I explain that as photographers and writers, we are observers and recorders of the world, real and imagined. Who we are and where we stand when we watch the world determines how we see and what we record. Children, like professional writers and photographers, must be familiar with the tools of their craft in order to be able to capture what they see; they need to be able to recognize basic concepts in writing and photography.

In creating the core concepts of Literacy through Photography, I have identified certain essential elements of photography such as framing, point of view, timing, and the use of symbols and details—all of which have

> My mother, father, brother, auntie, and my cousin-sister Hansi are living in my house. We have land, but I don't know how much. We don't have lots of money, but we're digging a well now and we're growing cucumbers.
> I'm not going to marry. I'll try to get a job and roam around. I don't want someone ordering me around. If my father will let me, I'll keep studying. When I don't do my homework he scolds me because I told him I wanted to study.
> Anyway, I'll work in the fields and earn fifty rupees a week. I know how to harvest any kind of crop—oats, cumin, everything.
>
> HANSI JHIVABHAI

My cousin-sister Kamu and Hansi are holding the mirror while I take a picture of myself
HANSI JHIVABHAI

parallels in writing. I ask students to think about, or apply, one or more of these concepts. For example, when the children are photographing themselves and their families, I ask them to concentrate on framing. While they are photographing their fantasies, I ask them to think about point of view. In the simplest terms, this comes down to a question like: what does the world look like if you are Michael Jordan, the basketball player? If we're talking about timing, we might wonder together what the best storytelling sequence is for a series of pictures.

As the students become more comfortable with the camera, I encourage them to expand their ideas about picture making but also stay close to subjects they feel deeply about. When they make self-portraits they learn that they can be the subject of their own photographs, that they can transform themselves into "characters."

The assignment to photograph dreams brings into play the children's imaginary world. Try shutting yourself and the kids in the darkroom; sit on the floor and tell each other your scariest dreams and most wonderful fantasies. The photographs that come out of these storytelling sessions often break new ground for the students. They begin to see that it's possible for them to produce any image they want.

Our role as teachers is to create a safe and respectful environment so students can feel free to draw on their personal experiences and fantasies; most crucial in making and viewing photographs is developing a sense of play and discovery that can lead to mutual understanding.

Framing

To quote out of context is the essence of the photographer's craft. His central problem is a simple one: what shall he include, what shall he reject? The line of decision between in and out is the picture's edge. While the draughtsman starts with the middle of the sheet, the photographer starts with the frame.

JOHN SZARKOWSKI, *The Photographer's Eye*

The critic and curator John Szarkowski's eloquent description of framing can apply, with slight modification, to almost all forms of art. When two people tell stories about the same event, what they remember and choose to tell is different. Each one of us, depending on who we are, will notice different things and choose different details to explain or emphasize. When writing a story or a description of a scene, we have to decide what to tell our readers and what not to tell them.

Juan Jesús, one of my students in Mexico, is blind in his right eye. He had difficulty seeing the same things his friends did. He complained that when his friends described things they'd done together, he couldn't join in the conversation because his friends' memories were visual. It was only when Juan Jesús made photographs with his classmates and could refer to the pictures, that he discovered he could take part in this visual recollecting.

Framing is perhaps the most difficult and important lesson in teaching photography. As Westerners, we are used to seeing our world framed by devices such as televisions and computer screens, and, of course, picture frames. Yet we rarely think about how our way of experiencing the world has been constricted by these ubiquitous rectangles.

In other cultures the notion of seeing this way can seem utterly foreign. My Colombian students, who lived in the hills above a small village that had only recently been electrified, had trouble framing their pictures to match what they thought they were seeing. For instance, instead of photographing someone's face the way a student wanted, she might photograph only the feet. After discussing the problem with some of the local teachers, I realized that not only did most of the children never watch television, they lived in thick-walled adobe houses without any windows. (Windows would have allowed precious warmth to escape during the frosty Andean nights.) They had literally never looked through any sort of framing device.

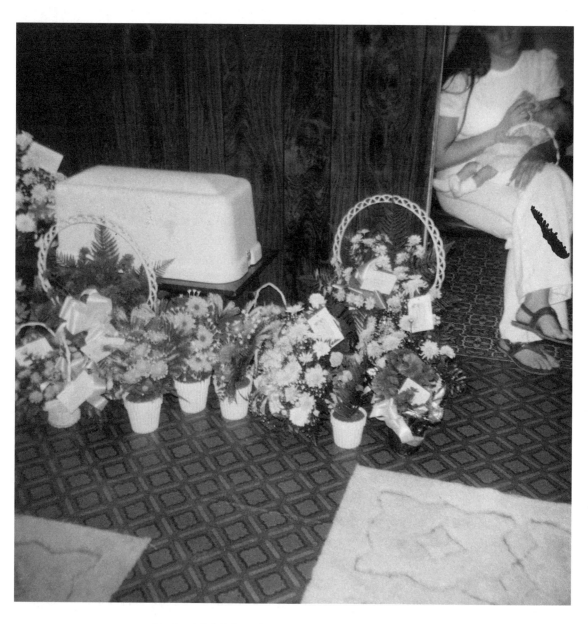

My sister's baby's funeral
THERESA ELDRIDGE

Many people, when they first take pictures, believe they should include everything in order to make the photograph they have in mind—they might insist that a portrait include everything from the subject's toes to the top of his head. I often see children hold the camera at a diagonal when photographing people. At first I marveled at this desire to experiment, but when asked what they are doing, the students usually tell me they are just trying to fit the feet and head into the frame.

A horizontally framed portrait taken with a 35mm camera will include a good deal of what is on either side of the person whose portrait is being made. At first this may not seem to be a problem, since our attention ordinarily gravitates toward the center of a picture. But when I talk about learning to frame according to what the students want to express with their pictures, I mean that we are forced to notice the edges of pictures. In other words, it's fair to assume that if something is in a photograph, even if that something is off to one side, the photographer must have had a reason for including it. A portrait is composed of relevant details. If a student takes a portrait of Aunt Sophia, she must be the most prominent element in the picture, and the space around her must give us clues as to who she is. In such a picture, the ceiling would probably be extraneous, whereas her favorite chair or teapot might be crucial.

Theresa Eldridge was one of my students in Kentucky. During the time she was in my class her sister's baby died. In keeping with the custom in Appalachia, Theresa photographed the funeral. Normally the casket would have been open, allowing for a final portrait to be taken. In this case, the coffin was a closed white box. If we look closely at Theresa Eldridge's sad photograph of the funeral, we see that she included many things other than the small closed box which is the picture's central subject. There are also flowers, cards of condolence, the linoleum floor, a paneled wall, a doorway, a seated woman in the upper right-hand corner, and throw rugs coming into the bottom of the frame

Theresa's job as a photographer who wanted to create a poignant picture was to decide what to include in the "frame." Instead of simply photographing the casket, she framed her picture to include a seated young woman feeding her baby. By including the woman with her baby, Theresa substituted the baby drinking its bottle for the unseen dead baby, which makes her sister's loss even more palpable. By showing this living baby and its mother, she also forces us to ask, "Who is this woman? Why is she

included here?" The ambiguity inherent in the image—did Theresa really mean to make the woman with the baby a metaphor for her sister's loss?—gives these questions great empathetic weight.

To answer these questions, we have to look for other details Theresa has chosen to show in her picture. The seated woman has her head down and cocked slightly toward the coffin. Theresa cropped the photograph so that the woman's eyes are at the very top of the frame, forcing us to look closely at her sad expression. We might assume from Theresa's choice in framing, and from the woman's expression, that it is her child who has died, but then we would ask, "Whose baby is she holding? Is she a close relative, or a friend and sympathetic mother?" How would we read the photograph of the woman and the baby if the casket weren't included? Without the casket in the frame, we might think she was simply the exhausted mother of a newborn.

I hesitate to talk about any norms or rules of composition. In the course of watching thousands of children make photographs, I have learned that they have their own sense of composition, formed by their immediate, intimate environments: How furniture is arranged in their homes, the toys in their rooms, the natural landscape around them. I see my role not as instructing but as encouraging, even inspiring, children to explore their own notions of composition.

With the first roll of film that one of my Kentucky students, Denise Dixon, took, I could see that she had a talent for composition. One of the first pictures she made was a photograph of one of her dolls in the doorway of her house. The picture was framed in close-up, at the doll's eye level, with her chubby arms in an arc in front of her. The result is something far different from the bland image you'd see in a toy catalog. Denise, by squatting down and taking the picture close-up, transforms her doll into her beloved friend, her equal.

I visited her at home several times. She had arranged her room so that it resembled an oversized dollhouse with stark white walls and a few posters of animals and family portraits. The careful decoration of her room and her dress were very like the care she took in the composition of her photographs. There were no extras, no frills, in any of them.

Sometimes, when a child is clearly disappointed by a photograph, I venture to talk about composition. I noticed after a few months that one of my Appalachian students, Maywood Campbell, was never quite satisfied

with her pictures. Looking at her negatives, I realized that she had chosen to photograph very intimate family moments. But unlike Denise's assured pictures, Maywood's compositions were a bit off. One photograph showed her little brother riding on her grandfather's shoulders. Their outstretched left arms were cut off. Maywood had tried to center her composition; when she couldn't manage this feat, it fell apart.

Her frustration came from not seeing in her pictures what she thought she was seeing in the viewfinder. Instead of talking about composition, I advised Maywood to walk around and just look through the camera for a few days. She became more aware of the edges of the frame formed by the camera's viewfinder and the movement of her own body in space.

Before your students take pictures, ask them to cut a small rectangle in a piece of notebook paper to represent the viewfinder of a camera, then to close one eye and hold the paper up to their other eye. Wherever they turn their head, they are seeing their surroundings through a frame.

Have them look to the side, and up, and down; ask them to move around and tell you what they see. Ask them to keep the paper with them for at least one whole day, to take it out and look at each new situation they find themselves in.

Just before you give out the first roll of film, ask your students to look through the camera at one object and write a description of what they can see, including where the edges of the frame are. Another interesting writing assignment is to ask the students to describe a scene as if they were a camera. They need to ask themselves two key questions: What is inside the frame? Outside the frame?

**Assignment:
Self-Portrait**

My self-portraits turn out well, so I like to take my picture. I keep my photographs in my school pass book so I look at them everyday to see what the features of my face look like.

CHANDU, INDIA

Framing has to do with how each one of us sees; like fingerprints or signatures, the way we see is unique. For this reason, I've paired framing with the concept of self-portraiture. I ask my students to explore the ways they can photograph themselves to best describe the singular beings they are.

We begin talking about self-portraiture by discussing what a portrait is. A portrait can be a written description, painting, sculpture, or photograph.

Denise Dixon making a
self-portrait
WENDY EWALD

Unlike a snapshot, however, or a conventional physical description, a portrait tells us something essential about the subject. I ask my students to consider portraiture throughout the history of photography, from portraits by Nadar (the pen name of Felix Tournachon, who worked in Paris in the mid-1800s) to contemporary portraits by Milton Rogovin. The students concentrate for a moment on the personality and social class of the photographers' subjects. From Nadar's simple portraits of people famous in his day, they learn that it's possible to create a meaningful likeness using only modeled light and drapes for props and background. From Rogovin's more detailed images, such as his portrait of a woman factory worker, they are able to see how physical particulars can provide crucial information.

As with all photography assignments, I've found it helpful to ask the students to write about what they are going to photograph before they actually shoot their self-portraits. Writing about the subject beforehand helps them focus their ideas about the kinds of pictures they might take.

One of my students, Robert Dean Smith, wrote a deceptively simple self-portrait that tells us what he looks like in relation to his parents. It also describes his temperament and suggests how he sees his life unfolding:

> I favor my dad, but I act just like myself. I'm sort of tall and fat. I'm almost as tall as my dad is, but I'm taller than Mom. I lose my temper a lot. When anybody makes me mad, I'm ready to fight.
>
> When I get older, I'd like to live in the same holler, I know that. It's just a peaceful place. I'd build a cabin and live in it. I'll probably follow after my dad. I'll work in the coal mines and just live right here.

At first I could not read any of Robert's writings. There were no spaces between the words, and he spelled everything phonetically. When I finally deciphered his style of verbal composition, I found he had written beautiful passages about things he'd been doing—what animals his hounds had tracked, or how the cornfield looked in the afternoon.

Another excellent exercise is to have the children look at the photographs afterward and, then, with the physical reality of the image in front of them, write about what they see. Both exercises can and should be used for each assignment. Ordinarily, the sequence goes: write, shoot, write. But the order of photography and writing can be swapped around to accommodate and reinforce the flow of the students' inspiration. The writing and the photography feed one another.

Usually I'll give the students ten or fifteen minutes to write about themselves without paying attention to structure, spelling, or other technical concerns. The idea is to encourage them to write freely, to create source material for their photographs. You might suggest they think about who they are in relation to their families; what they like to do; what they think about; what they look like; what makes them happy, sad, or mad; who the person is deep inside them that nobody sees; who the person is that everybody sees; what their future might be; and so forth.

Once they have a paragraph or two on paper, ask some of the students to read what they've written aloud. Ask what images are suggested by the writing. (I recall, in Robert Dean's case, talking to him about making images of him and his dad, of Robert Dean in a peaceful place with shadowed light, and of Robert Dean ready to fight.) Finally, you could ask the students to describe the photographs they would take, concentrating on what should be included in the frame.

Sometimes I'll ask my students to bring in pictures of themselves when they were younger. I'll ask them to write about what they had forgotten about themselves that the picture reveals. Who were they then? Najma Marks, an eighth-grader in Durham, lived in Miami as a child and still often visited her relations there. She brought in pictures of herself as an infant and as a preschooler dressed for church. She wrote the following poem:

> We lived in Miami.
> My mother always dressed
> me in white.
> They say I was flirting.
> Always smiled.
> Never was a mean
> baby. 5 months.
>
> My sister and I had long pig
> tails.
> Loved going to Dolphin shows.
> And my brothers
> never said anything.

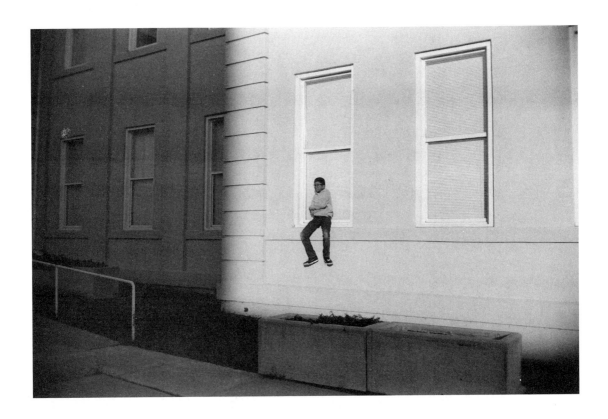

I am alone in the wilderness

PHILLIP LIVERPOOL

In photographic portraits, as in all portraits, information about the subject is determined by the expression on the subject's face, the gestures he is making with his body, the clothes he is wearing, and by what is surrounding him. The background might be nothing more than a wall; the wall might be light or dark. If it's dark, the person could appear isolated or lonely. Or sunlight might be streaking across his face, separating him from a somber background.

Phillip Liverpool created a self-portrait titled "I am alone in the wilderness." He had tested higher than any student in the history of his school, but he often found himself in trouble for not attending to tasks at hand. In his self-portrait he showed himself perched on the ledge of a school window with his arms wrapped around his waist. His expression is resigned, almost blank. Sunlight falls across the window and a portion of the wall surrounding him. The rest of the wall is in complete darkness, conveying the feeling that he is in an isolated and alien environment. His self-portrait conveys his "aloneness" in a "wilderness" that is empty of other life. His picture powerfully articulates his conception.

There are many special challenges to making a photographic self-portrait. The most difficult one is often a practical matter: how to stand in front of and behind the lens, how to be in two places at once. The inexpensive cameras used by my students do not have timers, so it is not possible for them to mount the camera on a tripod, press a button, and scurry in front of the lens before the shutter clicks.

The simplest solution is for the students to take a close-up self-portrait by holding the camera in front of their faces. They must hold the camera with their arms stretched out in front of them. This is an awkward solution, and it can make for a tedious sameness in framing.

Most often my students elect to make self-portraits by directing a friend or family member to snap the shutter for them. They have the person taking the picture stand in the place they want to be photographed while they look through the camera and decide exactly what they want in the frame. Once they determine the position, they swap places with their "assistant."

Whatever technique your students decide to use, they must first decide what to include in the frame. Do they want the viewer to see their entire face? What can they reveal in a picture of just eyes, a mouth, the right side of a face? In the background your student might want to include a statue in the park, a brother or sister, or a stuffed animal. Most importantly, before he or she clicks the shutter, what kind of expression does he or she want to capture? It is also important to tell the students that these photographs must be made outside on a bright day. Otherwise the glare of the flash might obscure facial features and ruin the portrait they hope to make.

Outside, they might want to make a portrait that is a reflection in water, a shadow, or in a mirror. Since shadows and reflections change with the angle of the sun, they might want to take these pictures at different times of day and in different poses. Ask them to notice how shadows change when they fall on things. (Again, these photographs need to be made without flash so the light doesn't bounce off the mirror or water, or saturate and obliterate the image.)

If a students uses a mirror, she is making a picture within a picture. How does that change what she is trying to say? She needs to decide what to include in the frame—just herself, or someone or something that gives the viewer a hint as to what she is like.

Your students can also make still life photographs of objects that reveal something about themselves. (A still life is a grouping of objects that have a relationship inside the frame of the painting or photograph.) They can make still lives of objects in the house that they dislike, or take a picture of their favorite clothes. In Saudi Arabia, where it is forbidden for adolescent girls and women to be photographed unveiled, one of my students used her school uniform to represent herself going through her day.

Ask your students to think about how they would take a portrait of the person deep inside themselves—the person nobody knows. Where would they place themselves—in a favorite spot? A bright space? A dark space? What would they wear? A gym uniform tells one story, Sunday clothes another. Maybe they'd like to dress up as they imagine themselves five years from now. What gesture or expression would they want to show the camera? Are they relaxed, annoyed, happy, crazy, funny? How would they show such states of mind, with their body position as well as their expression? These are tough questions but answering them and snapping the shutter can bring the student discovery, pleasure, and a real sense of accomplishment.

Assignment: Family

A family is a group of people that has more concern for each other than two friends would have. They share ideals. They share their feelings with each other. When you're part of a family you don't have to go home and talk to the wall. You have somebody that will reply back to you. There's always another person you can turn to. You kind of know where everybody is. You know your daughter lives next door and your cousin lives straight across from you. They visit you a lot. You're with them and you can talk to them.

GARY CRASE, KENTUCKY

The most important subject for my students is their families, and family photographs are the pictures they most commonly make. The challenge for students is to make photographs not just for their family albums but to explore and communicate their feelings about their family to others. This focus on family pictures seems instinctive, except in the Muslim world where portraiture is quasi-taboo. My Muslim students had difficulty making such pictures.

As with self-portraiture, I usually begin with writing exercises and ask the children to describe their families. Some of the questions I ask are: Who

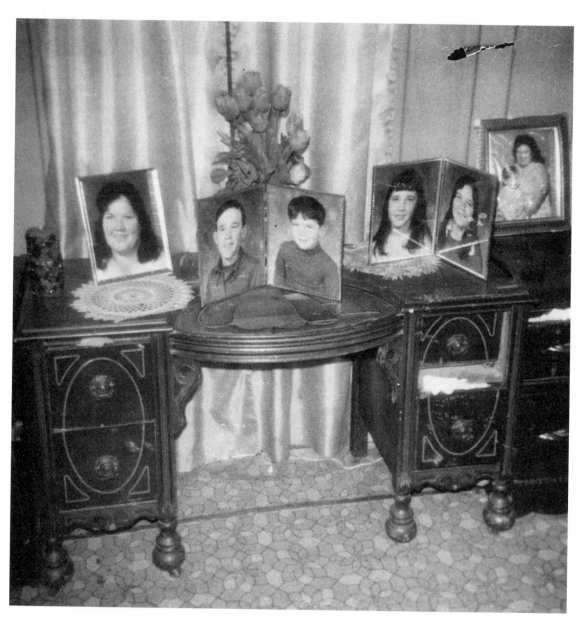

A portrait of my family

VERNON GAY CORNETT

is in your family? What do they do? How do you feel about your family as a whole? Who makes you mad? Who do you depend on? Who do you take care of? What do you wish your family was like?

For some students, questions about family bring up painful feelings and memories. In India, in response to the seemingly innocuous question "Who is in your family?," I learned that Sajjan's mother had been murdered by her father. It also came out that Chandrakant's grandmother had been drowned in a well, and Tidi's brother and sister had died of smallpox. These were troubling facts for me to learn, and clearly difficult for the children to recount.

A graduate student in my class at Duke University was studying family and child law while working with a group of elementary school students in Durham. Many of them were having trouble writing about their families. She decided to let the students use tape recorders to talk privately about their families. One fifth-grade boy began listing the members of his family and how he felt about each one. When he got to his father, he said matter of factly that he wished he saw him more often. Then he broke into sobs and kept repeating his hopeless desire over and over.

It's important to be aware of the feelings that may arise when urging my students to describe their inner and outer worlds. They may have had little opportunity to communicate their sense of loss or confusion, much less to change their circumstances. Sometimes it seems helpful simply to let them tell their stories.

For some children it can be intolerably stressful to write or talk about troubled aspects of their family lives. When there is illegal activity going on in the home, discussion about family life can get tricky. Don't push a child to talk about a traumatic incident or anything else she seems very reluctant to discuss. Every school has its guidelines; if you find yourself dealing with unsettling disclosures, it's imperative to consult the school's guidance counselor or social worker.

A parent of one of my students sold his camera (possibly to buy drugs). The boy was devastated. It was only after many conversations and repeated assurances that we began to understand what had happened. In such cases you should try to help the child move past the painful circumstance by encouraging him to draw on other personal resources that can enrich his life and compensate, at least partly, for the loss he may feel. On a practical level you could suggest that he write about and photograph an

Memorial Day

DARLENE WATTS

ideal family drawn from friends and teachers at school, the community center, or another place outside the home.

Once the students have shared some of their writing, ask them to make a list of ideas for photographs suggested by the writings—photographs they can make at home. Sometimes I'll ask my students to think beyond their immediate family to include their dog, cat, neighbor, or others they might want to include in their family. You can also ask the students to photograph the person in their family they feel closest to, paying particular attention to light and dark and to framing in order to show the love they feel. Or conversely, you might suggest they choose the person in their family they fight with the most, to show their anger.

I'll say my grandfather is in heaven because he would sit and read me the Bible every night before we'd go to sleep. He'd always tell me to be a good little girl. He had buried what he thought was important in his life. My grandma said he buried his wedding ring. He was a carpenter, and he buried the first little shelf he made. He said he was saving them for his most loved grandchild and that was me. When he died all the grandchildren cried but my grandpa always told me to be brave. He said don't cry at my funeral, but I cried anyway. Now when I'm feeling like I should not have cried about something, it seems like he comes down and tells me it's all right. I don't always have to feel guilty. Sometimes I think he's talking to me. I'll want to tell everybody, but it seems like every time I try to tell it something holds back and won't let go. It's just hard to tell.

DARLENE WATTS

Katharine Berry, who often fought with her brother, photographed him holding toy guns pointed at the camera. She took the picture on the street at dusk, leaving empty space around him. Her brother is highlighted and isolated by the flash, making him look dangerous and alone.

You might ask your students questions like: How can you take pictures that tell a story about your family without taking pictures of your family? How can you include yourself? Taking pictures of pictures can be a way of including people who are absent. Vernon Gay Cornett's photograph of framed family pictures arranged on a dresser is a good example. He was able to include himself in the picture (second from the left). Another way of "showing" absent subjects is to shift the context of the person photographed, as in a photograph Javier Reyes made of a framed portrait of his mother set among handmade pots. The pots refer to the ceramics made by the mother's Chibcha Indian ancestors. The use of symbolic detail expands the photograph's meaning to link Javier's mother with his family's and his people's history.

Once the family portraits are made, there are many ways the children can use them as sources for writing. You can start simply by asking the

students to describe what's happening in one of the pictures. They will need to look closely at the details, think about what they reveal, and pay close attention to what is inside and outside the frame. It's helpful to ask the students to swap pictures and write something about people they know little or nothing about. The photographer can then see if her intentions in making the picture have been communicated to her classmates. Another provocative exercise is to ask students to choose a portrait of one family member, in this case a grown-up, and write about themselves as if they were that adult at the moment the picture was taken. For example, if the mother is cooking, the student could write about what she thinks her mother is thinking and feeling as she stirs the pot. To do this, the student must project herself onto her mother's image, into her life, and this can let her begin to empathize more deeply with her mother.

Symbol

The critic and curator John Szarkowski once remarked that photographers are forever faced with the problem of portraying something they can see in their minds but can't readily photograph. Until digitalization came along, photography, unlike other visual media, was more or less stuck with representing the physical world naturalistically, as it presented itself to the lens. In order to symbolize what couldn't be shown directly, photographers had to use details. The concept behind this handicap is still enormously useful.

If you wanted to take a single photograph of, say, a baseball game that shows the essence of the sport to someone who had never seen it before, what would that picture be? If you took a picture of the whole field, with all the players in position, you would have to be so far away that very little of the actual game would be comprehensible. In other words, if you're far enough away to see everything, you're too far to understand anything. This is one reason why symbols (or details) are so useful. The most commonly used symbol for baseball is the bat and the ball; a newspaper story about a baseball game is often illustrated by a picture of a batter at the plate. And a picture of a crucial catch can be used as a symbol for the losing team's defeat.

Holidays—those commonplace but socially complicated events—can also be represented by symbols. Denise Dixon's turkey and Javier Reyes' crucifixion are two wonderful examples. When I asked Denise to document her family's Thanksgiving dinner, she produced a picture of the turkey on a plate on a bare Formica table, shot starkly, almost clinically, from above. Just as she did when decorating her room, Denise included only the essentials. Javier, a fifth-grader in Colombia, insisted that he could not imagine what pictures he could possibly take of Holy Week or Easter. Whereupon he went to the village cemetery and photographed a crucifix from below, accentuating the dark, stormy sky above and behind it.

The symbols chosen by Denise and Javier, as well as how they photographed them, evoke the meaning and emotion attached to holidays. The starkness of Denise's photograph is reminiscent of the Pilgrims' first, somewhat meager, Thanksgiving, and the framing and lighting of Javier's photograph suggest the tortuous drama of the Passion story.

When working as writers, we are not as tied to the physical world; we have a lot more freedom when it comes to describing a subject. Still, symbols or details remain important tools for conveying emotion or the essence of a situation. In simplest terms, what does the dawning of a sunny day usually mean in a story? Or a clock ticking on the wall?

Jesus Christ crucified
JAVIER REYES

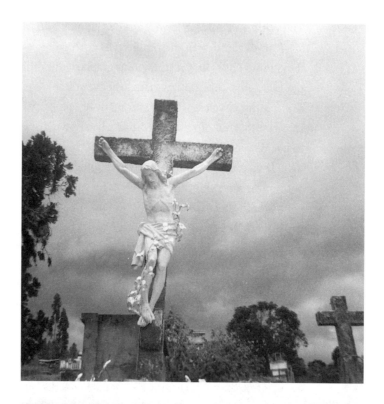

Thanksgiving
DENISE DIXON

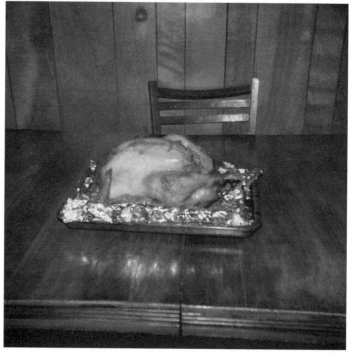

The first thing you might do when teaching your students about symbols is ask them to choose a subject to describe. School is an accessible topic, and one fraught with emotion. Ask them to write a description of school and their feelings about it. Then, working one-on-one or with a group, ask the students to make a list of the symbols that might represent the school itself, or a day at the school. The symbols can be objects or people. You can go on to ask them to suggest symbols for ideas and emotions that are less tangible. Boredom, for example, could be shown by the clock on the wall or a student's expressionless face cradled in her hands.

If you have time to continue the exercise, choose a group of the most popular symbols and have the students split up into groups to photograph them. Once the photographs have been made, you can ask the students to choose some of them to write a story about, paying particular attention to how the symbols can be used to convey emotion.

The students discover that it becomes progressively more difficult to find tangible details for feelings that are hard to specify. But it is possible to use the same exercise and ask the students to represent things that are relatively abstract, like friendship or fear. In the case of friendship, a symbolic representation could be someone holding a portrait of a friend who's far away; in the case of fear, an abandoned house with a lone figure emerging from a shadow. It's astonishing how often the students' rendering of such verbal commonplaces can transfigure clichés into evocative visual statements.

Assignment: Community

I'm glad that you people outside our village can see these photographs because you'll learn a lot about us. Don't praise us; we're nothing special, just ordinary country children.

JAVIER REYES, COLOMBIA

The communities we live in determine a good part of our lives. This is especially true for children, who are not able to move about as easily as adults. Yet we rarely examine what constitutes community. Putting into words or pictures a concept so vital and primal can seem impossible, as hard to define as scent or taste. Where does a community begin and end? What holds it together?

For this reason, a community is a particularly difficult subject to photograph. It's larger than our eyes can take in at a single glance, or even in a

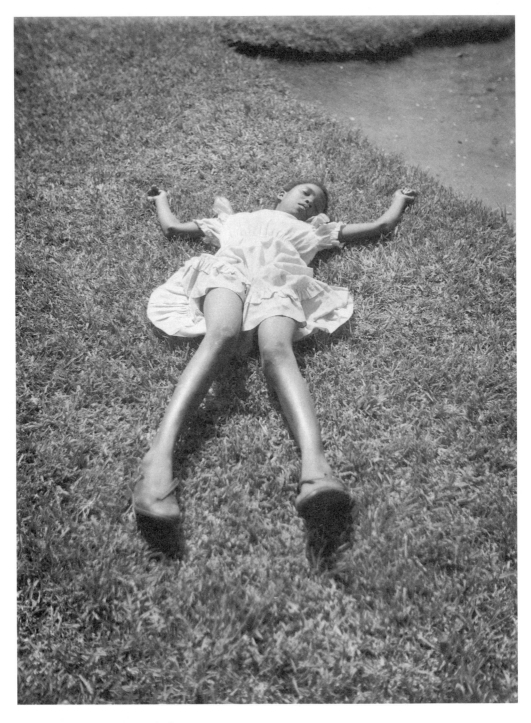

I am dead

PALESA MOLOHLOE

series of glances. It's also abstract—indeed, more an abstraction than a physical reality, which is why I couple it with the concept of using symbols to represent the whole.

Ineffable as "community" may be, the definition and description of its problems and strengths can be the first and, perhaps most important, step toward its development.

During the fall of 1992, when apartheid was still the law of the land, I was in South Africa working with white and black children in their separate communities. My black African students had lived through radical social change, and their struggle had been watched by the whole world. They were keenly aware of the power of photography to be a witness to situations that cry out for change and justice. When asked to photograph their community, they said they wanted to take pictures of the violence perpetrated by the Afrikaner police. They also spoke about domestic abuse in their neighborhood. But because of the violence all around them, they faced severe limitations on what they could photograph safely. The children in the apartheid-created black township of Soweto just outside Johannesburg were afraid to take pictures outside their homes, they said, because raising the camera to their eyes would limit their peripheral vision and make it hard for them to notice potential attackers.

It's not quiet around my house because there are drug dealers, troublemakers, and a lot of other things. The police are always around. But in the summer it's fun because the kids start to sprout. The drug dealers go away. They seem to go down into the ground. It's quiet at night. In the winter the drug dealers start to sprout again and the kids seem to fade away. And the grown-ups too start to wake up from their long summer nap.

TIFFANY BEST, NORTH CAROLINA

My Afrikaner students (Afrikaners are descendants of South Africa's original white settlers) feared the blacks who worked and attended soccer matches in their neighborhood. They stayed inside their tiny front yards behind bristling razor-wire fences.

For students from both these groups, it was particularly important to use symbols and re-enactments to represent their communities, and the successes and failures of their lives. Palesa, a student living in Soweto, photographed herself lying on the ground, as if shot dead by a police bullet. Many of the Afrikaner children, who lived in a lower-middle-class urban enclave, photographed their maids or "nanny girls" as representatives of the black population they feared.

At the conclusion of the project, both groups of students exhibited

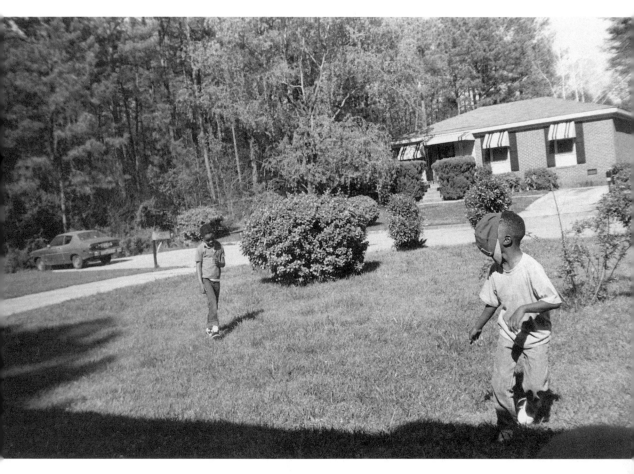

Don't be ashamed. Show your
face. Michael and my cousin in
our front yard.

TIFFANY BEST

their photographs in a gallery in downtown Johannesburg. Here the black and the white children met for the first time, and saw each others' pictures. They were very apprehensive. They took pictures of one another, monitoring how their rivals used their cameras. The Afrikaner students found it hard to believe that the African children were able to take crisp, well-exposed pictures.

By the end of the day, as I was taking the final group picture, all the children, black and white, threw their arms around each other. I realized then that it had been a mistake to work with the groups separately. Though I had acted on the advice of local advisers, I'd been too timid in the way I'd structured the program. It turned out, against expectations, that the children were quite capable of respecting each other as photographers, and then as South Africans. Sharing photographs of their communities was a way to begin the process.

In any case, the project helped them identify their problems, particularly the racism in the fearful and psychologically troubled Afrikaner community, and it was a step toward alerting concerned adults about the extent to which their children were deeply frightened by the changes looming ahead for the country.

> I could not believe that the Inkhatas were attacking us. I don't remember how it started. It lasted all night. I was scared. You could hear only gun shots. They were breaking windows and all those things. We locked all the doors and did everything we could to keep safe. We knelt down. I didn't do anything but pray. I was so angry. I was just thinking of taking a gun and going to shoot all those people. Kill all those Inkhata people like they never saw me. Take a bomb and throw it at them. The next morning when I was going to school, all the people's windows were broken. They found bullets in their houses. There were holes in the walls. I felt I was very lucky because they never came to our house. They just ended in the middle of the street. Right here.
>
> PALESA MOLOHLOE

Defining community can also stimulate discussions of pride in the students' culture and their traditions of caring for one another. When I first asked my Moroccan students what they most wanted to photograph, many of them said they wanted to photograph symbols of their heritage and the natural world that was part of their community.

> I want to take pictures of nature, but it's almost impossible because it's an expression that comes from my heart. I will take pictures of what's happening in our society. I will photograph Moroccan women fetching water from the well, the peasant tilling the earth, men making pots

What my mother wears to
occasions and parties
HMAMED TARIK

with their hands, and horsemen competing in the arena. I want to take pictures of our designs, sculpture, mosques, and what I love—Moroccan clothes, because these things are traditions from our heritage, from my grandmother and my mother.

—AMAL MALEK

I often suggest that the students begin writing about their community as if describing it to someone living on the other side of the world. What would they choose to talk about?

Joannie Williamson, who lives in Durham, North Carolina, wrote about her fears for her community with terrifying directness:

Williamson, my last name, Westend where I live, and war—all have something in common. The letter w. All my life I have lived in the part of town known by the gangsters as the "War Zone," known to the children as the "West End," and now to me as the place I must live until the day I die. It may be reversed, the day I die where I live.

My community can be summed up into three sections: bad, worse, and terrible. Just the other day two boys were shot. One died and the other is working on it. I guess you have a pretty good idea why. The big DRUGS. Most of the teenagers get along pretty well until they get into drugs.

Don't get me wrong it's not all bad, all of the time. In the summer for instance there's a little park near my house with a store down the street. The man who owns the store is known to everyone as Walker. He makes everyone feel safe.

My community is not as bad as I'm making it out to be. Well, yes it is, but I enjoy living there anyway. I'm just as crazy as I said it is.

Let me tell you about my neighbor (let's call him "Don't Know Why I Did It") who held up a gas station. He'd never done anything like this before. He has a job and his children and wife are well fed. I heard the sirens and had to see what was going on. When I got to his house all I heard him say was, "Don't know why I did it."

When I hear people talk about how rough the West End is my first response is, "No, it's not." But if you ask me to tell you about peace and serenity, I just shut my mouth and look away from the real truth.

I asked Joannie what images she saw in her mind as she was writing her piece and how she thought she might photograph them. She admitted that what she had in mind would be pretty tough to photograph, but she said she wanted to try to balance the image of the war zone with how people got along when their lives weren't affected by drugs.

After they've completed their writing assignments, ask the students to make a list of everything they can think of in their communities, from the postman to the children on the street to the corner grocery store. Then have them make a second list, dividing it into likes and dislikes. From this list choose one item. A favorite topic for "likes" is church. Ask the students to list as many things as they can that relate to religion—dressing to go to church, greetings outside the church building, singing, praying, going to weddings and funerals, as well as symbols or details that could be used to picture these activities.

A "dislike" that often comes up with young students is drug use and drug-related violence in their neighborhoods. Both are tough (not to mention dangerous) to photograph. And even if it were possible to safely take a picture of a drug deal, it would probably look like any other cash transaction. So instead, you might make a list of the effects of drug use or violence and the details that could represent them, such as an old crack house, graffiti, trash with crack vials in it, or the face or hands of someone known by the students to have a drug problem.

Drawing on the list they've made as a group, you could ask each student to pick a few items to photograph, making sure you've covered the list. Before the kids go out to shoot, suggest that they break their subjects down into possible shots. Once the photographs have been made, ask them to assemble the photographs into one portrait. If, however, the students live in different communities, they might photograph only as many items on the list as they felt were relevant. You might ask the students to make a list of controversial issues in their neighborhoods and divide them into teams. You could ask each team to report on the issues as photographers and reporters, again paying particular attention to the symbols that represent opposing sides of the issue.

The students should then choose the photographs they think best tell the story of their community. This could be done in smaller groups—each concentrating on a different aspect of the community—or in a single

group focusing on a general image of the community. Once they've chosen the photographs, they could arrange them in a sequence to create a visual narrative.

It's helpful, before getting too far along in this editing process, to look at some photographic essays from books or magazines and discuss the sequencing and editing choices made by the editors. We often consult magazines such as *DoubleTake* and *Aperture;* books by Bruce Davidson, Eugene Richards, W. Eugene Smith, and Helen Levitt; as well as photographs from the Farm Securities Administration. Once the students have sequenced their photographs, they can write a narrative to accompany the group portrait of their neighborhood. If they take pictures individually, they can each write their own piece using the symbols in the pictures to describe how it feels to live there. They can also swap photographs, create sequences about places unknown to them, and write fictional pieces about other students' neighborhoods.

Time

I like to wait to take my pictures when people are doing something special, like dancing, working, or at Christmas. I wait for the right moment, but sometimes I arrange things so that a mop or something untidy isn't in the picture, or I ask someone not to pass through. Sometimes I wait and nothing happens.

—DIAMEL VARGAS, COLOMBIA

Perhaps the most distinctive feature about photography is the way it freezes a fraction of a second. Photographers must chose which fraction, which fleeting glimpse, best reveals the subject. It might be a certain expression; a gesture; some action, like jumping in the air. It could be an instant in which everything in the frame falls into place and creates an interesting composition. It is what the French photographer Henri Cartier-Bresson called the "decisive moment."

Violeta Hernandez's picture of a merchant selling corn in the marketplace in San Cristóbal de las Casas is a good example of a decisive moment. Violeta, one of my Mexican students, took the picture just as a merchant was pulling two ears of corn out of the fire. He and the customer are looking at the corn, which seems to be floating in the air. Meanwhile, in the background, the life and movement of the town continue: In middle ground, a woman hugs her baby, while just behind her a woman with her back to us makes a phone call. In the center background, two women walk away from us; just to the right of them two bicyclists ride farther into the distance.

Another way to think about photography's special grip on time is to consider the way it can freeze an action in progress. Palesa, a twelve-year-old living in Soweto, took a photograph of her mother catching a ball. Palesa was particularly proud of this picture. She told me she was waiting for the truck to take her to Mofolo Park when she saw her mother jumping and catching the ball. She grabbed her camera and thought about how she wanted the picture to look. She chose the second just before the ball reached her mother's hands to click the shutter. The picture came out just as she thought it would.

Photography is unique in its ability to divide an action into segments of time that otherwise we would not see, or stop to contemplate. Luis Jimenez, a Mayan boy from Chiapas, created a story about his father. The story describes a single activity, farming, over the course of time. It begins

The marketplace

VIOLETA HERNANDEZ

with Luis's father pulling a hoe from a stack of tools. In the second picture, we see his father from behind as he walks to a field; in the following picture, he is weeding the field. In the fourth picture, he is harvesting lettuce, and in the fifth, he is seen carrying a sack full of lettuce, presumably heading toward home. You could begin studying photography's power over time by asking the class to select a situation that is changing. It might be what happens on the playground slide during recess. Ask each student to take a picture of the scene from the same spot. Then lay out a selection of the photographs and discuss how the fraction of time the camera has recorded in each case contributes to the meaning of what is seen.

To further explore the notion of time, ask your students to choose an activity in which someone or something is moving fast and to photograph it in a way that gives a sense of movement. Let's say the subject is a runner. Ask your students to take a picture of the runner from the side using the flash as the runner passes the camera, then from the front, then from the back. The flash captures an otherwise unseeable fraction of the action—the runner's feet in midstride.

Then ask the students to take a picture in the same way, but without the flash. The camera's shutter takes a much longer time to open and close than the flash takes to flash its powerful light. And snapping the picture more slowly means that as the runner passes, she will be blurred. The blurring of the figure enhances the effect of speed in relation to the background, which is sharp because it is not moving.

Finally, ask the students (still shooting without the flash) to follow the runner with the camera as they take the picture. The runner should be sharp because the camera is keeping up with her, but the background will be blurred. (Both runner and photographer are moving in relation to the background.) Each variation on this exercise should give the effect of speed in its own way.

Time and sequence are also crucial in writing. Emily Legge, a fourth-grader in Durham, wrote a piece that follows the sequence and movement of one day. Emily called her piece "My Full Packed Day."

> I am sitting on a swing outside thinking of something to do. I decided to ride my bike. I rode past the park down the street. I felt like it was raining cats and dogs, there were so many! I stopped riding my bike

because the dogs kept chasing me and I almost ran over a cat. Then my Mom called me and told me to get my cleats and shin guards and come on. Cleats? Shin guards? Why? I thought to myself.

"You have a soccer game," my mom reminded me.

At the beginning we were ahead by one. Then they got another point. There were only two minutes left in the game. A girl passed me the ball. I kicked it. I watched the ball fly through the air right into the goal! We won! And I kicked the winning goal. The score was 3 to 4.

When I got home, I felt like none of my bones were connected. When I got to my room I fell to my bed and fell asleep. I didn't even take my cleats off.

Emily's story is made up of one moment after another without pause. It gives the reader a sense of rushing through the day with her.

I spend some time talking with the students about how writers are not stuck with real time the way photographers are. Without going to any special technical fuss, writers can chose a particular moment for an action to occur, or they can change how it unfolds to better suit their story. Sometimes I ask the students to write a story, as Emily did, using only moments that can be seen. Or I turn the assignment around and ask them to write a story composed only of imagined moments.

Occasionally I'll ask my students to pick ten photographs at random, from their own work or their classmates', and make a sequential story from them, even though the photographs may not originally have had anything to do with one another. Then I'll ask them to write the story using the moments depicted in the photographs.

Another useful exercise to try with your students is to choose one of their photographs that shows an action stopped in time and ask the class to write a description of what is happening in that split-second—as well as what came before and what will come next. Action is not an easy thing to break down into separate elements, so it's interesting to notice how many different ideas there are about how an action might unfold.

Assignment: Picture Story

The aspects of photography we've talked about so far—framing, symbol, and time—are elements of static images separate from one another. But there is something else that photography does superbly well—storytelling, or narrative. The two pictures that begin James Dixon's book *Scary Things*

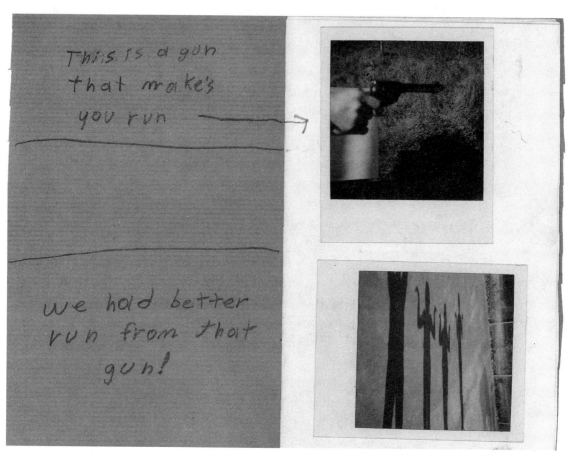

This is a gun
that make's
you run

we had better
run from that
gun!

From *Scary Things*
JAMES DIXON

describe a perilous situation by showing a gun in one photo and the shadows of the victims in the next.

The first and most basic method of using pictures to tell a story is simply to show the passage of time from one photograph to another, in the manner of cartoon panels. A more complex use of pictures to tell a narrative would be to describe a theme, the way Maywood Campbell did in Kentucky for her story titled "Work and Relaxation." Maywood began her narrative with the family's morning chores and continued by alternating moments of relaxation with periods of work until finally everyone went to bed. Maywood's classmate Myra Lynn Campbell created a book she called *The Life of Old People*. For this story she made portraits of the old people she knew.

You can begin by asking each student to write a one-line idea for a story. You might give them parameters as guides in thinking about time—something that happens in a single day, or something that's moving, or something that stays still. Using comic strips as a model, ask them to write a description or draw ten pictures that illustrate their story. If you're working on this project in class, try splitting the children into teams of four and choose one story to photograph. Once the stories are shot, ask the groups to swap stories and write their own narratives. This gives the photographers a chance to see how well their ideas get across, and it gives the other students an interesting starting point for their writing.

After the students have created their stories, you can make the decision whether or not to use text in displaying them. In order to show them the power of words to influence the reading of a photograph, cut out photographs from magazines and newspapers, omitting the captions. Ask the students to write their own captions and share their ideas before reading the original ones.

Similarly, when displaying the students' photographs, I almost always insist that they give titles to them so they can direct the viewer to their intentions. Sebastián Gómez Hernández took a wonderful picture of his little brother precariously perched in the top of a small tree wearing a cardboard mask with horns jutting out of its jaw. The title that Sebastian gave this picture ("The devil is spying on the girls") gives a sinister dimension to it. The devil figure becomes a scary, secretive being who, with dubious motives, is watching young girls who are just outside the picture frame. Maybe the devil is watching us too.

THE LIFE of OLD PeopLe
:::
MYRA. LyNN. CAMPBELL.

APRIL„ 14 – 19.80

It's very hard to think of being old.
And it's also scary. Because we know
we have almost lived a life time.

Many times we'll assemble text and pictures together in a book, on a poster, or in magazine format. This is a way for the students to organize and share their work with others. Perhaps the easiest method is to make posters by pasting photographs and related writings on standard poster board.

My most complicated project was a bookmaking workshop. Katy Homans, who designed this book, worked with my Kentucky students. We studied the history of printing and bookmaking. Then the students laid out and sewed their own books, using handwritten or hand-rubbed type for the words. The project ranged in complexity from James Dixon's two-picture story about a gun to Greg Cornett's *The Coal Miner's Life,* a thirty-six-page book complete with a title page and an ISBN number.

6

Being old can also be
lonely. Because theres no
one to help the old
with there work.

7

14

SOme old people
can only sit
around there house.

15

From *The Life of Old People*
MYRA LYNN CAMPBELL

Point of View

As photographers, we have almost godlike discretion when it comes to altering the appearance of things simply by where we look at them from—by changing our vantage point. By kneeling on the floor and looking up at our friends, we can transform them into giants; a teapot on a window ledge, seen close up, will dominate the landscape outside.

Most of my students start out by using a camera the way they use their eyes, by looking directly in front of them, at whatever presents itself at eye level. In the beginning, they don't really distinguish between their eyes and the camera. This makes for an off-kilter kind of obviousness that becomes conspicuous in their photographs of people. Often the students will cut off the bottom half of a person sitting down or include superfluous things like the wall and part of the ceiling above the figure. If they're making a portrait of someone standing up, they may inadvertently crop out the feet and include space above the person that adds nothing to the picture. It doesn't usually occur to beginning students that the camera could be angled downward a bit so that only the relevant details of their subject would be included. And they have yet to discover that in order to take a meaningful picture of their subject it's not always necessary to include the whole body.

The camera can be moved to emphasize different aspects of the subject. There is a simple geometry to it: If you photograph a subject from below, the angle will make an object appear larger than it does in reality; if you photograph it from above, it will appear smaller. As the subject becomes larger, it takes on a more powerful presence. Conversely, the subject's presence is diminished by photographing it from above.

Another compositional corollary: whatever is close to the camera will appear larger than objects or people farther away. Things that are close (and therefore relatively large) seem out of scale, and acquire importance in relation to the other things the eye is seeing at the same time.

Jungle Music III: Drew and Taylor, a photograph by Phillip Liverpool, is a wonderful example of this elementary, yet powerful, visual geometry. Looking down, Phillip photographed his cousins from a tree in his yard, and they look tiny underneath him. He included trunks and branches and shadows which are large and menacing in relation to the children. The children seem entangled, truly lost in a jungle.

What makes Phillip's photograph even more frightening is the presence of the photographer watching. The closest thing to the camera is

*Jungle Music III: Drew and
Taylor*
PHILLIP LIVERPOOL

Phillip's left leg. The monstrous leg appears large enough to crush the children below, which makes them appear even more vulnerable.

Another way of understanding point of view is to think about how other characters might look at the world. How does it look like to a small child? Or to an NBA player? Where, in these instances, would it be appropriate (or necessary) to put the camera?

When my son was four years old, I found it very useful to squat down to his level to see what he was seeing. This strategy profoundly changed my feelings about my surroundings and my own body. Seeing at the level of a small child, I could no longer look down at things in my living room, and it was not an easy thing to move past the couches, chairs, and table. The room looked like a maze.

I have the students start off with an exercise that can either be photographed or just viewed through the camera. I ask them to choose a subject, a single item such as a person or a bicycle. The background should be plain—a wall or an empty road. I have the students make a list of all the different angles from which they could take pictures of their subject. Then I ask them to use the camera to look at each angle they've listed and tell me how things change as they reposition themselves according to the list—from behind, from the side, from three feet as opposed to twenty feet, from above, from below, and so on.

Next I ask them to choose a scene comprised of two or more elements: a person at a dining-room table, say, or a swing set in a playground. I ask them to do the same exercise—listing all possible vantage points—but this time to notice how the elements change in relation to each other. What does the person sitting at the dining table convey when photographed close up, or from behind? What is the message if the person is photographed from the far end of the table?

Phillip Liverpool took a picture ("Izak, I'm going to fall") from a very dramatic perspective. The camera is at the bottom of a slide looking up at Izak, who's at the top, waving his hand in a way that suggests danger. The enormous slide diminishes in width as it goes upward until, at the very top, Izak's tiny head appears. Tree branches loom over him. Phillip's vantage point created an atmosphere of vulnerability for his subject.

Writers, too, can tell stories from different perspectives. In a workshop with Vietnamese American writer Lan Cao, the students read some of her novel, *Monkey Bridge,* about a girl moving to the United States after the fall of Saigon. They were inspired to write several pieces about moving. Bill Becker wrote first from his own perspective:

> If I moved to a different state I would be very disappointed. I'd feel just as empty as the house I was leaving.
>
> When I got to my new house, I'd be frightened. It would be easy to fill the house, but it would be hard to fill my heart. I'd always have memories of my old house.

Then Bill wrote from his father's perspective:

> One night I came home from work with great news! "We're moving," I told my family. My wife was happy, but my children ran to their rooms. I was surprised by the way my kids acted.
>
> I went upstairs to talk to them. They said, "We've lived here all our lives or most of them and we don't want to move." I told them they would make new friends and that I would make more money to support the family. But after what they said, I just couldn't move.

Assignment: Dreams

> To dream some of the dreams I've dreamed, my mind has to be five or six times as big as the world.
> DARLENE WATTS, KENTUCKY

> I think there are some things like clouds in my mind. When I imagine lots of things, the clouds fill up as if it's about to rain.
> TERESA LOPEZ, MEXICO

Some years ago, while staring out the window of my workspace in Kentucky, trying to plan my second year of teaching, I noticed a neighbor child lying down outside, flat on his stomach. His older brother was hogtying him, roping him wrists-to-ankles in imitation of a pig about to be slaughtered, a common event on the farms nearby.

The children in Kentucky often enacted such scenes. For them, the whole natural world was a playground, and as in dreams, their play easily crossed borders between life and death. I wondered how photography could tap into that world. What would it mean for students to be able to write

I am the girl with the snake
around her neck
DENISE DIXON

about and picture their dreams and fantasies? If vantage point is understood in a literal way—as the spot where the camera is placed in relation to the subject—is there also a sense in which the photographer's imagination can shift its stance? If the camera can change reality by looking at the world from different positions, can the camera also capture what it's like for the mind to change reality when it's dreaming?

Of course it can. Paradoxically, photography's tendency to be literal-minded, to render extraordinary things matter-of-factly, plays right into the fantastical. Young students instinctively grasp how everyday objects can become magical totems. A heating-oil tank can become an airplane; a dish towel, a wedding veil; an armchair, a spaceship . . .

I asked my new class in Kentucky to talk about what dreams were, where they came from, and to narrate some of the more memorable ones. To establish a receptive atmosphere for these sometimes frightening fantasies, we turned out the lights and sat on the floor of the darkroom.

Allen Shepherd told us about a dream in which he killed his best friend, Ricky Dixon. Denise Dixon dreamed of herself with a snake around her neck. Scott Huff had a dream about planes crashing on his head.

I asked the children to photograph these dreams as well as any fantasies they might think up.

Scott Huff hadn't had much luck with the photographs he'd been trying to take. Now, however, he strode in triumphantly carrying his roll of dream pictures. As for Allen Shepherd and his homicidal dream, it turned out that Allen and his friend/dream-victim, Ricky, had quarreled and hadn't been speaking to one other. When Allen made his dream picture of the "dead" Ricky's body draped in the fork of a tree, the stand-off ended.

> I always think about what I'm going to do before I take the picture. I have taken pictures of myself as Dolly Parton and Marilyn Monroe and then there was the girl with the snake around her neck. She was supposed to be a movie star, but really it was me.
>
> DENISE DIXON, KENTUCKY

Other ideas include describing life from the viewpoint of a character or an inanimate object—a raccoon or a bicycle—or to narrate a fantasy, as Denise Dixon did in her dream about her twin brothers, one of whom became a vampire and tried to kill the other one.

Since my years in Kentucky, I've asked students in many other places to tell me about their dreams. Not all of them were enthusiastic. Some of my students in India, the ones who were not able to go to school, claimed never to

I dreamt the twins tried to kill each other. Phillip was supposed to be dead but Jamie sees him floating in a tree.

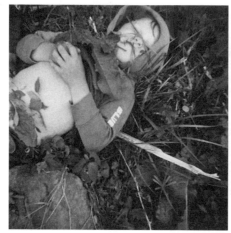

I dreamt the twins tried to kill each other. Phillip is a witch. Jamie has tried to kill him by driving a stake into his heart.

I dreamt the twins were trying to kill each other. Jamie is praying for help from his kin people who have died.
DENISE DIXON

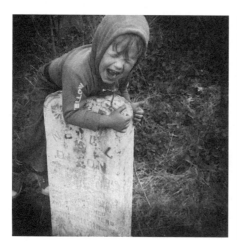

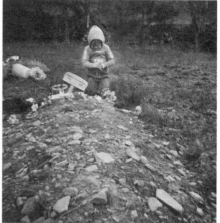

dream at all. In Colombia, Luis Arturo Gonzalez, a thirteen-year-old shepherd, said he spent his long solitary hours in the fields thinking only of his job, caring for the sheep.

> I made a long dream with Phillip and Jamie which comes from TV shows I've watched. I told Jamie to lay down and then I put all this makeup on him to make scars and scratches on his mouth down through his nose and on his hands.
> I put wood on top of him like a house fell on him, and I told him to act like he was dead.
> I took some in the graveyard above my house. For one I told Jamie to grab a hold of the gravestone and start screaming. For the other I told him to kneel down. I told him to bow down like he was sad. I took the picture from the foot of the grave that had just been filled
>
> DENISE DIXON

My students in South Africa had troubling dreams; their dream images were uncomfortably close to reality. In Orange Farm, a squatters' settlement outside Johannesburg, the children said they had difficulty imagining anything. Finally Bafana Radebe said that sometimes he saw his mother lying dead under a bloodied newspaper.

Other children in these countries, especially those who were able to attend school, spoke of active imaginary lives, and they were thrilled by the prospect of enacting stories about the gods, the saints, and other fantastical beings. It seemed that the children who lived in an environment in which they felt safe enough to fantasize and plan for the future could translate their rich dream worlds into images and words as powerful as any artist's.

(Psychologists would dispute, correctly, the insistence on the part of many subliterate children that they do not dream. It is generally agreed that all of us, children included, do dream. The issue would seem to be whether or not certain children feel entitled to dream.)

In Mexico, dreams play as important a part in the Mayan understanding of the world as do waking events. One day in our class in Chamula, some of the students turned up with masks they'd made from cracker boxes. Sebastián Hernández Gómez made a devil mask with horns coming out of its neck (and used it to make "The devil is spying on the girls," discussed earlier). Sebastian needed only to hear the word *sueños* or *fantásias* to begin planning his devil photographs.

While discussing dreams and fantasies with children calls for sensitivity and caution, the potential for self-expression and communication is tremendous. You can learn a great deal about your students' preoccupations and dreams for their future. Sometimes their fantasies might make you uncomfortable; sometimes they won't correspond to your idea of what's

appropriate. I think it's extremely important, however, not to be afraid, and not to censor what is for the children very real and filled with emotion.

I was asked once to conduct a workshop for a local arts council in South Carolina. Some of the parents of the children involved happened to be colleagues familiar with my work. They were particularly intrigued by the dream project. They'd seen some of the startling pictures made by children in Kentucky and Colombia. They suggested I do a similar project with their children, most of whom were very bright and from middle-class homes.

After a week of working together, we hung the students' pictures and writings on the walls of the arts council's headquarters. The material included scenes of death and violence, just as the Kentucky and Colombian children's had. When the parents saw the work, they were visibly upset. Some confided that they hadn't expected that the dreams of their own children, who lived relatively comfortable lives, would be so disturbing.

Even more important than the sometimes unsettled reactions of adults are the things children unwittingly tell us about themselves and their lives. I was recently reminded of this in a particularly sad way. Samju was one of the liveliest and most dedicated of my photography students in India. She was the daughter of a farmer, and she did not go to school. She was extremely independent for a girl, and outspoken about her feelings. When I explained the dream assignment to the students, she was outraged. How could I ask them to photograph their dreams, she demanded. I explained what some of the students in Kentucky had done, but that didn't help. "You might have fooled those other children in those other places," Samju said, "but you're not going to fool me. It's just not possible!" I smiled at her determination and assured her that I would not trick her; she could do the assignment or not as she pleased.

A few years later I had occasion to review a conversation I had tape-recorded with Samju in which her troubled view of her future became clear.

"I want to die," she said, "so I don't have to get married. Girls have troubles after they marry. We have to leave our parents, and that is sad. Our in-laws will beat us. Now I can work or sleep as I like."

"Last night," she continued, "I had a dream that Uncle Dhanji poured kerosene on our house and lit it on fire and the whole house was burning down when I opened my eyes, but I didn't scream. We have bad dreams— no happy dreams."

Clearly, for Samju to picture her dreams was an upsetting prospect.

Shortly after listening again to my interview with her, I received a letter from one of my other Indian students, a former classmate of Samju, now in his early twenties. He said he'd learned that Samju had recently "gone to heaven." She had gotten married and, in uncanny fulfillment of her girlhood nightmare, had become a victim of the not-uncommon crime of "bride burning."

In contrast, when Denise Dixon was asked to photograph her dreams, she saw the assignment as a chance to transform herself and her surroundings. For her, the changing of dreams into pictures was fun. She explained some of the ways in which she played with her feelings of fear and pleasure:

> I like to take pictures from my dreams, from television, or just from my imagination. I like those kind of pictures because they're scary. If I didn't know how I took them, I'd be scared by them. My twin brothers, Phillip and Jamie, pose for me. Sometimes they're good at having their picture taken, but they get tired of it.

This is powerful stuff, so it's important to lay a groundwork for generating safe discussions of dreams and fantasies. In addition to sharing our dreams, I like to ask students what they think dreams are and where they come from.

Jayanti, one of my Indian students, told me that "God raises his hand and sends dreams to us. This morning in my dream I was wondering about when we die—where we'll go. Do we go to America?" In Mexico, Benjamin Molina told me that "When you sleep, your soul goes off and everything that happens to it—that's what you dream."

The children and I also talk about the meaning the children's parents or grandparents assign to dreams. In many cultures dreams are prophetic. Like many children who feel their thoughts and feelings can cause things to happen in the world, Denise Dixon was frightened of her dreams. "If I have a dream where somebody I know dies," she said, "then they usually do die. One time I dreamed there was a baby in a casket, and one of its eyes was out. The next day my friend Libby's baby died and they say it had one eye open."

My Mayan students ascribed the most explicit meanings to dreams. María Auxiliadora told me that if you see a turkey moving toward you in a dream, it means that someone might kill you or rob you, while if you saw

a storm and an animal in the sky, you should sleep on the ground because you're going to get sick and you don't want to hurt yourself when you fall down.

Whatever the cultural context, students should of course feel free to express their own and their community's ideas about dreams, even if they are different, or shocking to the instructor.

After our preliminary discussions, I ask the students to write very quickly three dreams they can remember, or to make up ones if they can't remember anything, paying attention to the images that come to mind. Then I ask some of the students to read what they have written aloud and encourage the class to suggest a few photographs that could be made to describe each dream.

At this point we begin talking about the various vantage points and tones they could use to reinforce the feeling of the dream. Let's say someone dreamed about a frightening dog. How could he photograph the dog to make it look frightening? We've already talked about getting down low and taking a picture looking up at the subject. Now maybe the dog would have its mouth open as if about to bite.

Another useful technique is the use of light and dark to create a mood. If it's nighttime and the dog is outside and he is the only thing lit by the flash, he will appear more menacing than if photographed in the yard during the reassuring light of day.

I like to ask students to break into small groups to help each other write descriptive lists of the photographs they will make at home. If they have trouble coming up with ideas, I'll suggest they think about staging a nightmare or the most dramatic dream they remember. If they can't remember their dreams, I'll ask them to consider staging fantasies about their futures or their worries, or their desires for the world's future. I'll also ask them to look to the past for ideas. What would you and your surroundings look like if you lived ten, thirty, fifty years ago? What can you remember being afraid of, or excited by, as a child?

I usually suggest that the students create single images, or make multiple images that tell a dream story. The pictures seem to be more successful if they think of them one at a time. Otherwise they become illustrations of an idea rather than evocative images. Just as in the self-portrait assignment, the students can be their own subjects and ask someone else to snap the shutter.

Costumes and props are usually necessary for the dream assignment. Sometimes I'll bring props into the classroom so that we can make a few photographs as a group. (An interesting exercise is to photograph a dream scene without people, using only objects.)

Once the photographs are made, they are a wonderful source for writing. The dream assignment is especially effective in adding emotional charge to a story. How do the objects in the pictures add to the feeling of the picture? How does the placement of these things affect the feeling? How does the light, or the absence of light affect it?

In addition to having the students write stories based on their own dream pictures, I'll ask them to exchange one photograph, or perhaps a series of photographs, with a partner, while withholding the story behind the pictures. Then I ask the partner to rewrite the dream story looking for clues by concentrating on where the camera was placed. When dealing with a series of pictures, I'll ask the students to make up their own sequence for their partner's pictures and write a story to accompany them.

Getting Technical

The cameras can help make our minds more agile. And for those of us who know how to use a camera now, it's important that we keep taking pictures.

CAROLINA DE JESÚS DE LA CRUZ SÁNCHEZ, MEXICO

I'm not frightened anymore of photography. The best part is that we learned the best way: we took the cameras, we made pictures in the street, we came back here to the studio, we talked about the mistakes we made so as not to repeat them.

HENANE, MOROCCO

When I take a picture of someone, I'll ask him not to look at the camera. I tell him to look to this or that side, otherwise the photographs will be a statue not as person. In my mind I think, for example, I'd like to take Baldev, the barber's son's picture, so I'll go and find him and take his picture. I also like to take pictures of birds and animals. I like the colors of the birds. I'll have to use a coloring roll for them.

CHANDRAKANT, INDIA

Sometimes when I watch my students composing their first photographs or developing and printing their first roll of film, I feel as if I too were learning photography for the first time. The developing tank, the reels, and the changing bag once again become magical instruments. Watching the children straightening their backs against the weight of the camera, I remember how it felt when I had my first camera hung over my shoulder, how it conferred authority on me, masking my shyness.

Photography is democratic. The entire process, from using a camera to developing and printing, is easy to learn and accessible to almost anyone. Many of the children I've worked with are the lowest-ranking members of their community. Yet over and over they tell me that when they pick up a camera and decide what to photograph, they feel proud.

Mastery of the photographic process can represent a kind of power for many who have never had the opportunity to present themselves and the world as they see it. My students in Colombia lived in a village where ceramic pots had been made in the same way since pre-Colombian times,

Two boys learning to use the camera
WENDY EWALD

Anastasio Gomez shows his photograph to his neighbors
WENDY EWALD

and tourists often photographed the villagers making pots. A fifth-grader named Dalida Reyes told me how glad she was that people outside the village could see her pictures. "I'm proud to know how to pick up the camera and take pictures. The tourists always come to take pictures of us when we're making pots. When I was small I was excited by it. I never thought about why they were doing it. Now I'm ashamed to think I might look funny or distracted in pictures that might end up in a newspaper or movie."

I've seen my students' status rise in their communities as a result of knowing how to handle a camera and how to develop and print their own pictures—skills most adults haven't mastered. "I teach my brothers and sisters and the other kids how to use the camera," Javier Reyes, a small ten-year-old Colombian boy, said. "But sometimes the older kids see me with the camera and they say, 'Hey, you don't know how to take pictures.' So I have to take their picture and give it to them to prove it. Who knows? One day I could be a professional."

Pratap, the son of a wine maker in a rural Indian village, quaked with nervousness the first time he handled the camera. "We are not worthy

to touch the cameras," he announced to his fellow low-caste students. But within two weeks Pratap was posing his subjects with authority and developing his own film. And when we took a field trip to a bird sanctuary that attracted Indian travelers, Pratap managed, within an hour of arrival, to start selling his Polaroid pictures to the tourists for ten rupees a piece so that he could buy his own tickets for the boat and pony rides.

I've often seen my students' self-confidence increase along with their expertise. For children who've had little success in school or other learning situations, developing the technical skills of photography can help them focus on a series of physical tasks, with tangible results. My Colombian elementary school students, most of whom were attending their last year of school, brought the same sense of craftsmanship they used in making pots to developing and printing their pictures; they damaged not a single roll of film.

In the next section we'll look at the camera and the simple, flexible technical processes we use in Literacy through Photography. Even if the reader is familiar with the photographic process, the explanations could be helpful in teaching children or others new to photography.

The Camera

In the village in India where I held my photography classes, I had the delicate task of choosing which children would participate. My advisers, the village barber and his daughter, suggested that in the interest of impartiality we should chose twenty students on the basis of a basic test. The next morning a line of children wound out of the barber's yard on to the sandy road linking the village to the highway. One by one, I asked the children to look through my camera, identify what they saw, tell me what they wanted to take pictures of, and why. Most of the children said the same thing: that they wanted to make *photas* of the gods.

I asked Dasrath, the cobbler's son, to show me a *phota*. He pointed to the fanciful images of Hanuman, the winged monkey god, and of Krishna, the beautiful blue man-god adorning the front of the barber's house. It became clear that for Dasrath the camera was a machine that could manufacture any image conjured in his mind—just as easily as it could record what was actually in front of his eyes. In fact, many of the children didn't know it was necessary to point the camera at something in the real world!

To understand the students' concept of photography and to dispel any confusion before they learn to use the camera, I always ask, "What is

a camera? How does a picture get inside it?" Then I explain that the camera is simply a box with a tiny hole on one side, which can be covered or uncovered to let light in. On the opposite side of the box is a piece of photographic film or paper that captures the picture.

I also give them a brief photographic history beginning with the *camera oscura*, a device used by Leonardo da Vinci and other fifteenth-century artists as an aide for drawing. I ask them to imagine that the room we are sitting in—a classroom, typically, with windows looking onto the playground—is a kind of box. Just outside the window is a slide. It's time for fourth-grade recess, and kids are sliding down the slide.

How an eye works
SARAH DRAP

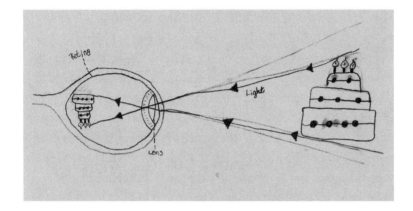

Now I ask my students to pretend that all the windows and doors are covered with black plastic and we've turned off the lights so it's completely dark. Then we put a tiny hole in the black plastic that covers the window. If we look on the opposite wall we should be able to see an image of what's outside—only the children will be climbing down the slide, and sliding up. The picture on the wall would be upside down—just like the picture that comes into our eyes but is rendered right-side up by the brain. (There is a mirror inside modern cameras to flip the image.)

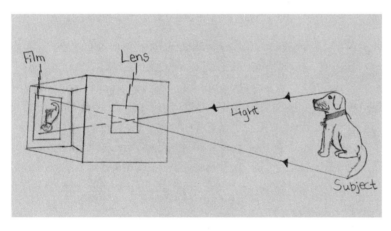

How a camera works
CAROLINE MCCRAW

If this was the image that da Vinci saw in his *camera oscura*, he would have put a sheet of paper on the wall. On it he could see the children sliding, and he'd trace what he saw. Then he might have made a painting from the drawing. This technique was called "drawing from light."

These days we have film, so we don't need to trace the picture that

comes into the camera—though if we were to put a sheet of film on the wall, the film would record the image in much the same way as da Vinci's bulky apparatus.

A 35mm point-and-shoot camera, the most common amateur camera, is a black box similar to the *camera oscura*. To the basic configuration it adds a lens (a piece of curved clear plastic in the case of a modest point-and-shoot camera) that sharpens the image and a shutter that opens and closes. When you open the back of a camera and push the shutter button, you see a hole in the lens (the aperture) opening and closing, briefly letting in light. There is also a larger rectangle toward the back of the camera. It is thirty-five millimeters wide, the exact shape and size of your negative. This is where the name of the 35mm camera comes from. The film lays on top of this rectangle. When the aperture opens, it makes a picture on the piece of film inside the rectangle.

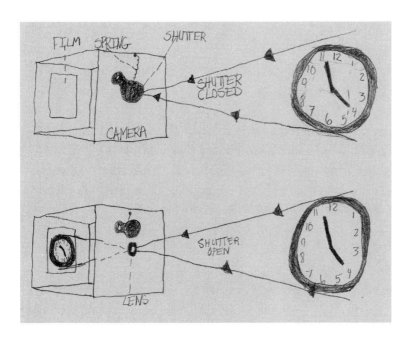

How a shutter works
JADE SHIELDS

How, I ask my students, is the camera different from the imaginary *camera oscura* we've made from the classroom? The main difference, I point out, is that a lens, made of curved pieces of plastic or glass, has replaced the hole in the black plastic. The lens makes the image that comes into the camera appear clearer. Some lenses can also be focused on a particular part of the picture to make that part even sharper, and other parts blurry, or out of focus. In most amateur point-and-shoot cameras the lens contains a shutter, a device that controls how long the film is exposed to light. Imagine that you were to cover the hole in the black plastic with your hand; when you withdrew and replaced your hand, light would come into the camera, much in the way a shutter acts. In a point and shoot the shutter stays open for approximately one-sixtieth of a second.

There are different kinds of lenses. The three basic ones are normal, wide angle, and telephoto. When you look through a camera with a normal lens, things look just as they would if you were looking at them without the camera. With a telephoto lens, things look closer, and with a wide-angle lens, things look farther away.

Most amateur cameras come equipped with wide-angle lenses. "Look through the viewfinder," I tell the students when I first pass out the cameras. "Do things look bigger or smaller?" They should look smaller, or farther away. Most children will notice this without any prompting. In fact, if the process is explained in language they understand, children's perceptions and their ability to pick up the technology surpasses that of the adults I've worked with.

There is a simple exercise I use in which the students imitate a camera with a lens that changes from wide angle to telephoto. I ask them to take a piece of paper and poke a hole in it the size of the lens on their camera. Then I ask them to close one eye and hold the hole in the paper to the other eye. What do they see? Now, with one eye still closed, I ask them to begin slowly moving the paper away from their eyes until it's at arm's length. What do they see as the paper moves away? They should see less as it moves away.

What they are actually doing, I explain, is pretending that their eye is the film and that the hole in the paper is the front of the camera lens. The widest angle is when the paper is next to their face; the most telephoto angle is when the paper is at arm's length. The longer the lens (or the farther away from their face the paper is), the larger things are going to look.

In photography, convention calls for assigning each lens a number in millimeters. Just as in the exercise with the eye and the paper, this number refers to the distance between the lens and the film. On a 35mm camera, a "normal" lens is 50mm. Numbers less than 50mm designate wide-angle lenses, everything greater than 50mm is a telephoto lens.

Most lenses on amateur cameras are 34mm, so things look just a little farther away than normal. I ask my students to examine how the lens is set back into the camera. The distance between the lens and the film on their point-and-shoot cameras is usually only thirty-four millimeters, and this short distance makes the world appear farther from them. It's like the piece of paper when held flat on their face, I tell them. Conversely, if they've ever seen very long lenses, the distance between the tip of the lens

and the film is so great that the photographer will be able to bring something in the distance very close.

Camera Options When it comes to picking cameras, the possibilities are endless. It happens that the cameras I use most with children are 35mm amateur cameras. There are three basic types. The first two have fixed-focus lenses, which means that the camera is set to focus eight to ten feet from the lens. Everything in front of and behind the focus point will be slightly out of focus. Unless you get closer than five feet, though, most shots will *look* in focus. The obvious advantage of fixed-focus cameras is that you don't have to bother with focusing the camera.

The cheaper fixed-focus cameras come with manually operated winding mechanisms. Slightly higher-priced fixed-focus cameras have automatic winding mechanisms, which advance the film after each shot. When the roll is finished it will automatically rewind it back into the film canister. All point-and-shoot cameras come with a rudimentary light sensor that tells the camera how much light is available; in keeping with this measurement, it controls how long the shutter stays open.

There is a third type of camera—one that comes with auto-focus and auto-rewind. It is considerably more expensive. Auto-focus means that you can focus the camera on a particular spot by aiming the camera at that spot and pushing the shutter halfway down. You have more control over the way your picture will look than with a fixed-focus camera. Generally, the results are sharper. But if the child forgets to focus, or focuses incorrectly, the subject of his picture may be wildly out of focus.

Here are two basic questions to ask when looking for a camera to use with students: How close can you focus with the camera (the closer the better), and what is the range of the flash? The range of the flash varies with the type of film you are using, but in general the more powerful the flash, the better.

Try shooting a couple of rolls of film with a camera you are considering. Make sure it is reasonably easy for the students to load the film. Check the rewind mechanism. If it is automatic, there is usually a button which, when pushed, will rewind the film at any point in the roll. Make sure the button can't be confused with the shutter or triggered accidentally. Make tests using the flash at different distances from a subject to check the strength of the flash and how it illuminates the scene. You don't want a

flash that's either too bright for the foreground, or so dim that it doesn't reach beyond a few feet. Most importantly, check to see if any light is leaking into the camera and adding extraneous streaks to the photographs. Also make sure that one negative doesn't overlap another. There should be a clear, even space between each negative.

Of course, there are options other than 35mm cameras. With children, the most commonly used alternatives are Polaroid cameras, throwaway cameras, and digital cameras. The great advantage of using a Polaroid or digital camera is that you are able to see the picture within seconds. If the student's photograph isn't what she anticipated, she can correct her mistakes. When possible, I use Polaroids at the beginning of a workshop, especially to help with framing. As the students become more confident with the camera, I'll switch to cameras that use traditional film—if I'm able to use a darkroom. In situations where darkrooms aren't available or time is a problem, Polaroid is a fine alternative.

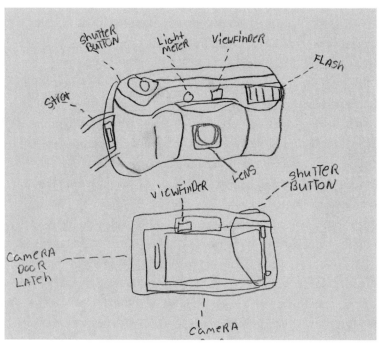

Parts of a camera
ANTONIO NESBITT

I use two types of Polaroid cameras with my students: the One-Step makes three-and-a-half-inch square images that pop out of the camera. The Polaroid ProPack, which is similar to older model Polaroid cameras and therefore familiar to most people, makes 3½ x 4½ pictures that must be pulled out of the camera. One reason I prefer to use the Polaroid ProPack camera is that a great range of films is available for it.

The biggest benefit of the ProPack, however, is that since the camera is quite cumbersome and complicated to operate, it slows the students down. They have to take time and think about each image they are going to make. They have to adjust the shutter speed and focus by adjusting the lens to the proper number of feet or meters.

Children often have trouble estimating distance. Some time ago I devised a solution that called for measuring each student's foot and calculating, along with the students, how many steps would make a foot or a meter. My Mayan students were quick to inform me that this trick of measuring their feet was inappropriate. They demonstrated the "correct" way by using their machetes to cut dried corn stalks into one-meter lengths. Then, using the corn stalks like rulers, they measured the distance between themselves and their subjects.

The film I prefer to use with the ProPack is positive/negative film. It yields a fine grained 3¼ x 4¼ negative, as well as a positive print. (There is no color positive-negative film; it's exclusively black and white.) With this film, you have the great advantage of being able to make high-quality copies from the negative. Also, the large-format negatives can be drawn on with permanent markers or scratched to alter the image. This provides a wonderful opportunity to teach kids about positive and negative images. If you want to end up with black words, you scratch letters backwards in the dense, black area on the emulsion side (the dull side) of the negative. If you want white letters, write as you normally would (left to right) in a clear area, on the shiny side, with a black marker.

Processing this positive-negative film, though a bit of extra work, is exciting to the students. After taking the picture and pulling it out of the camera, they must carefully peel the positive image away from the negative. Then they put the negative in a plastic bucket filled with a solution of sodium sulfite and water, which separates the negative from its opaque backing. When the Mayan students, laden with cameras and buckets and corn stalks, set out through the mist-shrouded mountains of Chiapas to make photographs, they looked like actors in a ritual play.

Still other options include throwaway cameras and digital cameras. Throwaway cameras were first made to be used on trips when people had forgotten to take their real cameras along. Because throwaways don't need to be cared for, they became an option for people doing short-term projects with children. Technically they're not bad, if they have a flash. In the end, however, it's much more expensive to keep purchasing them than it is to buy a point-and-shoot camera and replace just the film. Three throwaway cameras cost about as much as one fixed-focus 35mm camera. Throwaway cameras can also send a message to the students that the only camera you trust them with is disposable; they don't have to care for it the same way

they would a *real* camera. This may also lead them to feel that their relationship to photography is superficial and short-lived.

I am constantly being asked about the possibility of using digital cameras. With more and more computers in schools, digital photography seems an attractive option. Digital photography, like Polaroid technology, allows students to make pictures without the expense of a darkroom or processing. They can also put a digital image on a Web site and transmit it via e-mail in a matter of seconds. And with programs such as Photoshop, they can manipulate their images in endless ways, and create collages that mix images with text.

But the resolution, or sharpness, of digital cameras is not nearly as good as the resolution of 35mm point-and-shoot cameras. And there is an odd handicap in using digital cameras: there is a lag between the time you push the shutter and the actual moment when the image is taken (or "stored"). So if you try to take a photograph of someone clapping at the instant when her hands meet, the photograph that is stored may be of her hands wide apart. And with digital cameras you don't have the variety of film—color, black and white, and slide—that you have with conventional cameras.

The start-up costs of digital photography are considerable. An adequate digital camera costs two or three times as much as a conventional point-and-shoot camera. On top of this, there's the cost of the computer and printer needed to complete the package. Plus, a digital camera's batteries need to be replaced or recharged as often as every thirty photographs. It is hard to imagine being able to afford enough digital cameras and their essential accessories so that all the students in a class could have one to work with on their own at home.

It's possible, though, to get many of the benefits of digital technology by using a scanner along with relatively cheap 35mm cameras. With a scanner, the high-resolution 35mm photographs can be digitized into a computer, manipulated, and transmitted. If a good film scanner is too pricey for your budget, there is the option of asking your local photo processor to send your film to Kodak to be scanned and burned onto a Kodak Photo CD. The CD can be used to input the photographs into the computer.

The sheer force of technical novelty is sure to bring more digital technology into photography, and into the schools. But keep in mind that with any of the digital options, you and your students will lose the sense of discovery and accomplishment that comes with experiencing the magic of the photographic process from beginning to final print.

What Is Film? Film is any substance—usually translucent, like paper, plastic, or glass—which has been coated with light-sensitive silver halide salts. The earliest film was made with paper by an Englishman named William Henry Fox-Talbot. Before very long Fox-Talbot's process was made more stable by painting the silver halide on glass rather than paper. In 1889, George Eastman, the founder of the Eastman Kodak Company, made the first flexible film on celluloid. Celluloid, however, is dangerously flammable, so in the 1940s Kodak began making Safety Film, which is made of acetate, and is what we use now.

Today there are many different kinds of film made for 35mm cameras. Some of my students thought that a particular kind of camera made a particular kind of picture. One of the first things my Indian students wanted to know was why we weren't using a "coloring camera." I had to explain that you can make different types of pictures with almost any camera; mostly it depends on the film you use.

The three basic kinds of film are color print film, color slide film, and black-and-white film. Color film is coated with three layers of silver salts, instead of just one layer, as black-and-white film is. Each layer of color film is sensitive to a different color—blue, green, or red. When the three layers are combined, they make one multicolored image.

Some films, I go on to explain, are more sensitive to light than others. More sensitive (or "fast") films need less light to make a picture. The sensitivity ("speed") of each kind of film is designated by a number, which is known as the ASA. As with cars and miles per hour, the higher the ASA, the faster, or more sensitive, the film. The lower the ASA number, the more light the film needs. The most common films have ASAs of 100, 200, and 400.

When shooting indoors, or when shooting outside in shadows, I'll suggest to my students that they might want to use a film with an ASA of 400 because this is relatively fast and needs a lot less light than bright sunlight to make a well-exposed picture. If they are shooting outside on a bright day, they could use an ASA 100 film. An ASA 400 film, though, is a good multipurpose film to use with children. It will work in almost any situation. This fast, 400 ASA film may get overexposed when used outdoors, but it is often possible to correct for overexposure in printing—a fix that doesn't work so well when slower films have been underexposed.

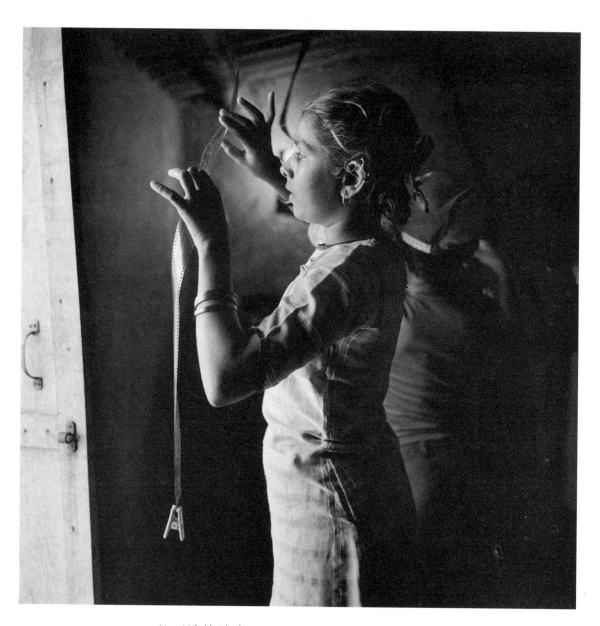

Hansi Ukabhai looking at
her negatives
WENDY EWALD

I'm often asked why I prefer to use black-and-white film instead of color film. Actually I use what I think is most appropriate for the situation. Whenever possible, I like to give my students a basic experience of the entire photographic process, which includes learning to develop and print their own pictures. In many situations I've been able to build low-cost black-and-white darkrooms. Color film is much more difficult to develop and print, and a color darkroom is prohibitively expensive to equip.

My suggestion is to let the teaching situation determine the equipment and the kind of film you use. When I was working in a mountain village in Colombia, where conditions were primitive, I got together with a local artist and built a darkroom in a run-down colonial building, so the children were able to develop and print during the months we worked together. But when you don't have the time or facilities to develop or print black-and-white pictures, color photographs work very well. In Saudi Arabia, I was able to work with my students for only two weeks, not long enough to develop and print the projects we wanted to do. Kodak offered to develop our color film free of charge, so naturally we used color film.

At first many children think of black-and-white pictures as old or lacking in richness. I often think of a joke a Colombian child once told me: When you take pictures of *el mundo subdesarrollado* (the underdeveloped world), the pictures, regardless of what film or camera you use, always turn out in black and white. The idea of poverty exists even in images of itself!

It is sometimes necessary to remind ourselves that a photograph does not record the world as we see it; it transfigures the world into something else, into a picture. Clearly, a black-and-white photograph is something other than the scene it depicts. When this "something other" communicates the photographer's feelings or ideas about what he's showing us, the picture is successful.

I spend quite a bit of time talking with my students about using black-and-white tones to create emotion in their photographs. A girl in a white dress, for example, if she is photographed sitting in a large, dark room, looks threatened by a sinister environment. Yet the same composition photographed in color, with the girl in a yellow dress, in a room with blue walls, can feel charming or romantic.

When the students are able to develop and print their own pictures in very simple, inexpensive darkrooms, they can heighten the mood of the photograph according to the way they print it. In the case of the black-and-white

photograph of the girl sitting in the room, they might make the room darker than it originally appeared, or they might erase reassuringly homey details, such as a picture on a wall.

After a while, most of my students begin to see black-and-white photography as a more expressive way to make pictures. They are able to take control of their pictures from the time they press the shutter to the making of their final print. They come to see the black-and-white photograph as something different from a color snapshot, as something special, something they were able to make.

How to Use a Camera

Learning to handle a camera properly is perhaps the most important skill I teach my students. Negatives that are blurry, underexposed, or overexposed frustrate the students and impair their chances of accomplishing what they want. The ability to produce a well-exposed, sharp photograph is within the grasp of children as young as five.

The first thing that I insist my students do is put the camera strap around their wrist or neck. This not only prevents dropping the camera, but also keeps the strap from drooping across the lens when they are taking a picture (creating large, rope-like white lines across their photograph).

Holding a camera comes naturally to most of us, but not for everyone. It's sometimes difficult for a child to decide which eye to use to look through the viewfinder, or difficult to close one eye, so that the image she sees is not two overlapping images. Hansi, a student of mine in India who was not able to go to school because she was responsible for cleaning her house, was an extreme example of this. She would press the camera against the bridge of her nose, and it was only after much persuasion that she moved the camera to the right and used her right eye. (Hansi also tried to advance the film before she clicked the shutter. Learning to do something in sequence was utterly foreign to her.) I have found that if a child favors their right hand, it is usually natural for them to use their right eye to look through the viewfinder.

I show my students how to hold the camera—where to put their hands so that there is maximum support and the least possibility of putting their fingers in front of the lens. Most 35mm cameras are contoured in a way that makes it natural to the hold the camera correctly.

The camera, I tell my students, has two eyes: the viewfinder on top and the lens in the middle of the camera. The viewfinder is your eye—what

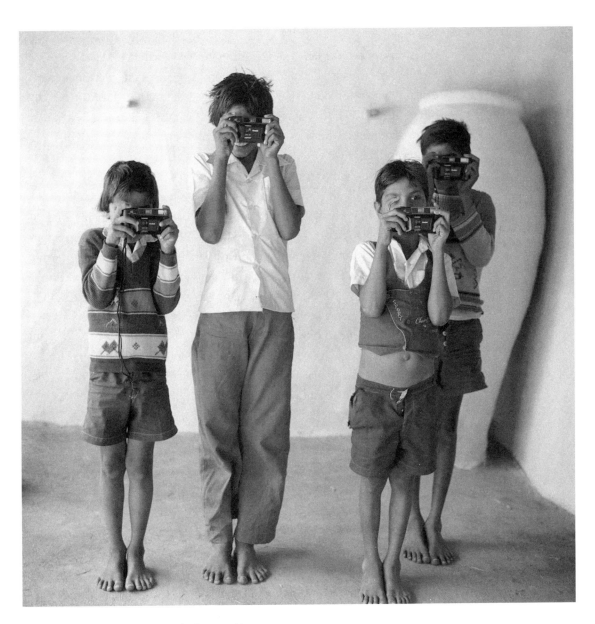

Harshad, Hasmukh,
Chandrakant, and Dasrath
learning to hold the camera
WENDY EWALD

you look through to decide how to frame the picture. The lens is the camera's eye. It determines what the camera sees and puts on the film. The two eyes don't see exactly the same thing. Try asking your students to put a finger in front of the lens and look through the viewfinder. Most of them can't see the finger. Then ask them to put a finger over the viewfinder and explain that even though they see their finger, the camera does not. Another difference between the camera's two eyes is that the lens sees a little bit more than the viewfinder, so the edges of their picture might include things they didn't see.

In the students' eagerness to capture what's in front of them, the most common mistake they make is to move the camera while they're clicking the shutter. To remedy this, you might want to teach your students an exaggerated camera stance: feet together, elbows at their sides as they raise the camera to shoot. Ask them to grip the camera tightly and hold their breath as they push down the shutter. Only the shutter finger should move at that moment. Then watch them snap the shutter of an empty camera. Ask them to take their cameras home for a few days—without film—and suggest they ask a family member to watch them shoot.

Many cameras have flashes that go off every time the shutter is activated. Some cameras have a sensor that tells the flash when the film needs more light and automatically triggers the flash. In cases like this, when flash is not optional, you have little control over the light in your photographs. If there is an option to use flash, I tell my students that when shooting indoors they must always use the flash, no matter how bright it seems.

Our eyes are different from the camera's lens, and what looks bright to our marvelously adaptable eyes can be dim to the camera. Sunlight is much brighter than just about any artificial light. If it is shady or cloudy outside, suggest to your students that they use the flash. If they are taking pictures outside on a very sunny day and can see shadows, they also might use the flash. In this situation the flash can brighten the shadows. For example, if half of their subject's face is in shadow and the other in sun, the flash will make the shadow side brighter and won't affect the bright side. Using the flash in this instance will make the light look more even.

Another discussion I always have with students concerns the range of a flash. It varies from camera to camera, but it's usually between five and fifteen feet. I use the analogy of a flashlight to explain it: If you get too close to your subject with the flash, it's like shining a flashlight in someone's

face; your picture will be very bright, almost white. The details of the face will be obliterated. Similarly, if you shine a flashlight at a distant object in the dark, the beam will disappear. So if you take a flash picture from too far away, the flash won't reach the scene and the picture will turn out dark.

Manual and automatic rewind cameras are loaded in much the same way. Described in words, the process seems more complicated than it really is. Loading these cameras is quite easy; once you get the feel of it, it's second nature.

I tell the students to put the bottom of the film canister into the hole on the left side of the open camera. They should pull out just enough film from the canister so they can thread the end into a slot or marking on the take-up spindle on the right. They must make sure the perforations of the film lay on top of the teeth of the small reel to the left of the take-up reel. The teeth will catch in the perforations of the film and move it forward. Remind your students that if the teeth don't catch, they'll think they're taking pictures and mov-

Loading film
KRISTEN CAMPBELL

ing the film along, but really all they'll be doing is exposing the same small piece of film over and over—in effect, ruining all the pictures.

With an automatic rewind camera, all that's needed after threading the film is to close the back of the camera. With a manual-wind camera, you must crank the winder, the mechanism that rotates the take-up reel, until you see that the film is moving. Then close the back of the camera and click and advance the film until you see the number 1 in the frame counter.

You can't stress strongly enough with your students not to open the back of the camera once the film is loaded, not for any reason, not until they've rewound it safely back into the canister. If the camera does gets opened, light will hit whatever film is not still in the canister, obliterating the pictures that have been taken. The film the light hits will turn black when developed. Also, the film counter will go back to S (start) when the

back is opened in mid-roll. Sometimes I'll have the students put masking tape over the back of the camera and write **Do Not Open** on the tape. In any case, I ask them to keep the camera in a safe place, so no one can accidentally open the back.

With a manual camera it's not possible to click the shutter or advance the film any further once the roll has been completely shot. All the film that started out in the metal canister has been wound onto the take-up reel on the right. Now it must be wound back into the light-tight canister. If the students are using a manual rewind camera, tell them to wind the film until they feel no resistance. With an automatic rewind camera, there will be a whirring sound as the film rewinds. When it stops, they can open the back of the camera. If the camera fails to rewind or stops rewinding in the middle of the roll, the batteries are probably dead or weak. Once the batteries are replaced, the film will continue to rewind.

Batteries are used to operate the flash and the shutter and sometimes, in auto-focus cameras, the focusing mechanism. You can use up a lot of batteries if the students don't learn to conserve them. In many cameras, when you push back the door that covers the lens, the batteries are activated. To save batteries, ask the students to keep their cameras closed when they're not using them. I also request that they not use the flash or snap the shutter unless they're actually taking a picture.

The children's excitement with picture taking can make for some rough camera handling. And sometimes, when one of the kids comes up with a good idea that's easily imitated, it gets overused. You might try limiting the times when the children can use the cameras. I try to keep things under control at school by asking them only to take pictures when we're working as a group. The rest of the time, they should be working at home.

Every few weeks it's helpful to review the students' photographs and negatives. Discuss with them what they like taking pictures of and what their problems are, then make suggestions about what they might try next. Some of the children make frequent technical mistakes that are easy to spot and correct. The concept of lighting, or when to use a flash, is often difficult for some of the children to get hold of; it needs repeating while you look at their photographs. These technical problems can merge into aesthetic ones, in which case the discussion can be as freewheeling or mechanical as the problem calls for.

The Darkroom

I thought you were playing mischief with us when you said you'd teach us to develop our pictures. I thought it was just talk and we'd never touch the enlarger. We all thought you'd tell us to sit quietly in the black room.

The first pictures we took were of you. Then I learned how to develop and enlarge pictures. I taught the others how to do it. I think I know everything. I know how to make a test strip. I didn't know what it was called before. I didn't know how to set the timer of the enlarger either. That was a hard thing for me.

CHANDU, INDIA

Although it isn't absolutely necessary for the students to develop and print their own photographs, it is tremendously satisfying. At first the process seems beyond their reach, something that only professionals do. But the children take great pride in learning all the steps in the process. For many students I've worked with who've been characterized as "at risk" (meaning students with problems that handicap their ability to function in school), this is an opportunity to stay focused on one activity that can hold their interest.

Developing and printing negatives are fairly basic processes; most children can become adept at them in two to three weeks. The students are able to understand and control each part of the technology. The traditional photographic process has many magical moments, such as when a photograph appears on a white sheet of paper in the developer. Each step can be concretely explained so the students are able to grasp it and manipulate the image as they please.

There are other educational and social benefits to mastering the process—learning how to follow steps in sequence is but one of them. Another is learning how to use mathematical equations to adjust the developing time of the negative in relation to the temperature of the developer. On a more human level—this observation has been made by several teachers I've worked with—the shared experience of waiting in a darkened space and watching prints develop gives some students a chance to communicate intimately, and eases them into making friendships across races.

Building and equipping a darkroom need not be expensive or difficult. I've converted classrooms, boiler rooms, bathrooms, and utility closets into darkrooms. In India, where it was impossible to make the tile roofs of the

Temporary darkroom in
migrant summer school
program
WENDY EWALD

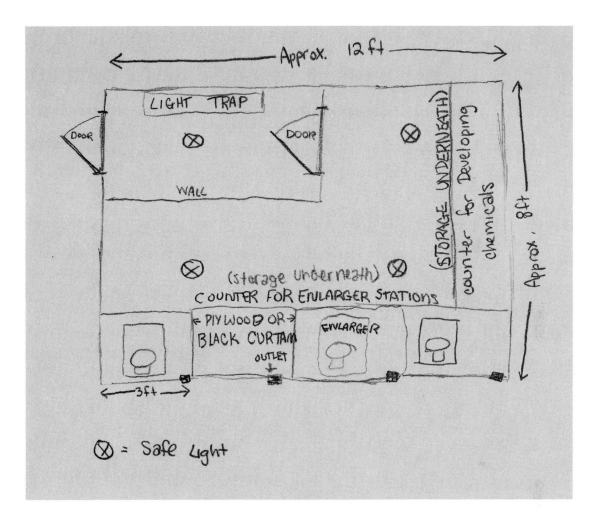

Inside the diagram:

Approx. 12 ft

LIGHT TRAP

DOOR ⊗ Door ⊗

WALL

(STORAGE UNDERNEATH)
counter for Developing chemicals

Approx. 8 ft

⊗ (storage underneath) ⊗
COUNTER FOR ENLARGER STATIONS

← PLYWOOD OR → ENLARGER
BLACK CURTAIN
OUTLET

3 ft

⊗ = Safe Light

Darkroom diagram
LUCY TRUMBULL

mud houses light-tight, we built a concrete-block darkroom with a tin roof
in the barber's front yard. Alongside this new building, the barber contin-
ued to cut and shave the hair of the village men. When the building was
finished we planted a ritual basil plant (basil being sacred to Krishna) to give
the "black house," as the darkroom was called, an auspicious beginning.

Ideally, I like to use an existing room, at least four-by-eight feet, that
adjoins a space that can be used as a classroom. Of course, the more space
you have the better. It is absolutely necessary, however, to build a light trap
so that no stray light enters the darkroom when people enter and leave it.
Commercial light traps, constructed along the lines of revolving cylinders,
are available. They take up very little room but are more expensive than the
handmade version—which amounts to a door-height box with a four-by-four

footprint, which has an outside door and an inside door connecting to the darkroom. The light trap allows students to enter the darkroom while others are printing without letting light in.

It is important that your students understand that a darkroom has to be absolutely light-tight. Go in the darkroom with a group of students and turn out all the lights. Sit for about ten minutes, looking as hard as you can for any light, especially at the seams of the room or around the door. If you do see spots of light, use duct tape or caulk to fill them in at the seams, or use black weather stripping around the door. Then repeat the process to make sure you've corrected the problem.

Inside the darkroom you need space for a minimum of four enlargers and a counter for chemical trays. The room is used only for printing and doesn't always have water; for that you can use the adjoining space. Outside the darkroom, in the adjoining "wet" space, students mix chemicals for developing and wash prints. They can also develop their film using changing bags, light-tight cloth and vinyl bags inside of which they roll their exposed film onto reels that are then placed in light-tight tanks. It's possible to have one group of students printing in the darkroom while another is outside developing film or writing.

For Literacy through Photography we buy no-frills, inexpensive equipment that can be replaced easily and cheaply. For classes of up to thirty students, we suggest you outfit your darkroom with four to six enlargers and enough tanks, reels, and changing bags to develop ten rolls of film at a time. If you have limited time and resources, you should allocate one roll of film per project per student when working in black and white and two rolls when working in color. For a classroom of thirty (which we hope you don't have; ten is an ideal number), see Photographic Supplies opposite.

Darkroom Equipment

FOR DEVELOPING FILM

5 Master changing bags

5 Patterson universal tanks with
reels

1 package Patterson 35mm film reels
(six in a package)

1 Calumet film washer

5 can openers

5 pairs of scissors

1 bag of clothes pins

1 clothesline

FOR PRINTING

4 Beseler Cadet II enlargers

4 Time-O-Lite darkroom timers
(to be used with the enlargers)

4 Ganz 5 x 7 Speed-EZ easels

2 Ganz 8 x 10 Speed-EZ easels

5 8 x 10 developing trays

1 8-inch Premier squeegee

1 set of three bamboo tongs
with rubber tips

1 Gra-Lab darkroom timer

2 Yankee safelights

2 Premier standard dial
thermometers

10 32-ounce measuring cups

6 plastic gallon jugs

1 16-ounce funnel

(In 2000, the cost of all this equip-
ment came to just over $1,800.)

Photographic Supplies

BLACK AND WHITE

30 rolls Kodak Tri-X Film, 24 exposures

1 package 35mm negative pages
(100 per package)

60 AA batteries

5 gallon packages Kodak D-76

5 gallon packages Kodak Dektol

5 gallon packages Kodak Fixer

1 pint Kodak stop bath

1 pint orbit bath

1 four-ounce bottle Edwal Hypo Check

1 Box Kodak 8 x 10 Polymax RC paper—
250 sheets

1 Box Kodak 5 x 7 Polymax RC paper—
500 sheets

1 16-ounce bottle Kodak Photo-Flo

(In 2000, the total price of all these
supplies was $382.)

COLOR

60 rolls Fujicolor 200 ASA film

60 rolls color processing

60 AA batteries

(Approximate total in 2000 was $365.)

The Negative

When my Mayan students saw the negatives of the first pictures I took of them, they burst out laughing. "We look like *viejitos* (little old people)," said one of the girls. She was referring to the fact that in the negatives her black hair appeared white.

Photochemistry is such that black-and-white film negatives change the polarity of light and dark as we see it in the natural world. If you take a picture of a black cat on the beach on a sunny day, the bright beach will be black on the negative, while the black cat will be clear.

What happens is a sequence of physical and chemical events: Later, when the shutter is opened, light hits the film inside the camera. The light-sensitive silver salts, which coat the film, are transformed by the light. When the film is put into the developer, the silver salts that have been touched by the light turn dark, while the silver salts on parts of the film not touched by light become clear.

This developed film is called a negative. The negative is used to make pictures or prints. In the printing process, the polarity of light and dark is re-reversed—it is restored to what we're accustomed to seeing in the natural

Positive and negative of Mayan students with a ProPack camera
WENDY EWALD

world. From a negative you can make as many pictures as you want, whatever size you want.

If you are using black-and-white film, the first and most crucial step is developing the film, which means making the negatives from which you will print the pictures. The film has a transparent plastic base coated with a light-sensitive emulsion. The emulsion consists of gelatin and silver-halide crystals. The gelatin binds the crystals to the plastic base, while the silver-halide crystals trap the light.

Light acts like a glue binding the silver crystals together. When the film is exposed to light, the crystals clump together. Later, when the film is in the developer, these clumps of silver turn black. In the later part of the developing process, unexposed crystals are removed from the film. The photographic image consists of different thicknesses of silver on the film.

The first step in developing film is to remove it from the camera after it has been rewound. Then you have to roll the film onto plastic reels which will be placed in a light-tight tank, or canister. Each canister that we use holds two rolls of film.

This transfer of the film from camera to canister must be done in absolute darkness, so that no light will touch the film. To do this we use changing bags. The changing bag has two black pouches, or compartments, and each pouch is zippered so that the compartments can be isolated from each other. The compartments serve as light traps for one another.

The student puts the film, a can opener (used for prying open the film canister), a pair of scissors, and the developing tank, along with the reel, post, and funnel for the tank into the inner compartment of the changing bag. The student zips up both the inner and outer compartments of the changing bag and puts her hands into the sleeves of the bag. (The sleeves have elasticized cuffs to keep light from entering.)

Now she can touch the items in the bag and begin working. It is essential for her to remember that until the film is transferred to the developing tank and the top screwed securely on the tank, she must not pull her hands out of the changing bag.

(This strict rule can lead to comical situations. Several times—more frequently, it would seem, than chance might call for—when my students were at work in their changing bags, the fire-drill bell sounded, and the children had to race out of the school with the changing bags hanging from

their arms. In a pinch, of course, you can take the student to the darkroom, have him pull his hands out of the changing bag, and leave the bag in the darkroom.)

With hands inside the changing bag, the student must first open the top of the film canister with the can opener, just as you would open a soft drink, and remove the film. There is a leader on the film which must be trimmed, so that the film is an even width. Once the film is evenly cut, the film must be rolled onto the developing reel, a spool that keeps the film surfaces separate, allowing the chemicals to touch the entire film surface. We use plastic reels, but there are other kinds to choose from.

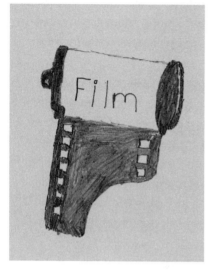

Film leader
TREMAINE COLLINS

This is the trickiest part of the technical process, rather like cooking in the dark. Some students have great difficulty with it, but give them a chance to work it out. If in the end they aren't able to roll the film, you can take the film inside the darkroom and roll it for them there. Next time you can pair the student with someone who's proficient at it. She can roll both students' film, while the other takes charge of the next step.

Once the film is on the reel, it's placed in the canister, with the top securely screwed on. Now the student can safely remove her hands from the changing bag and take out the canister. (The top of the canister cannot be removed until the film has been developed.)

Preparing Chemicals

Preparing chemicals you will use to develop the film or make prints from the negatives is something you can do with your students or on your own. It's often messy, but students can benefit from seeing how this part of the process is prepared. The most important thing is to read the instructions on the bags of powdered chemicals and bottles of liquid chemicals carefully. The dry chemicals must be dissolved in water at specific temperatures. These temperatures are critical, and vary from chemical to chemical. You will need to use a thermometer.

Most of the chemicals used in modern black-and-white darkrooms are safe. As with all chemicals, common sense should dictate your exposure levels. It's important, for example, to use tongs for all paper processes, and to wear rubber gloves when handling chemicals. There are indications that long-term exposure may lead to allergic reactions in certain people, but this

is very rare. Specifics about chemicals can be found through manufacturers' Web sites.

Advanced darkrooms have mechanisms to ensure consistent water temperatures and efficient ventilation. If you are thinking about setting up a more advanced darkroom, you would do well to consult one of the many books on darkroom design.

Before you begin, make sure the jugs and funnels you're using are clean. Also make sure the funnels are dry. For each chemical you mix, it is crucial that you agitate, or shake the chemical jug thoroughly. The powdered chemicals need a lot of shaking in order to dissolve properly. It's best to add them slowly. This will prevent clumping or clotting of the powder at the bottom of the jugs.

The developers—D-76 for film, Dektol for prints—are mixed in much the same way. Each comes in a powdered form. The powder must be dissolved in hot water—125 degrees Fahrenheit for D-76, 90–100 degrees Fahrenheit for Dektol. These chemicals cannot actually be used at these temperatures. They'll need to be prepared at least a day in advance, so they can cool to room temperature. When dissolved in water according to the instructions on the package, they make a stock solution. This means that before you actually use the chemical, it needs to be further dissolved in water. Mix D-76 and water in equal parts. Dektol is mixed two parts water, one part developer.

Developing Film

The developer reacts with the film to make the image visible. D-76 developer works to bind together the exposed silver crystals and turn them into clumps of dark metallic silver. The more light that has hit the film, the denser the silver.

The developing time is determined by the type of film, the type of film developer, the dilution of that developer, and the temperature of the solution. It is very important to measure the temperature of the developer, because it will affect the developing time. I normally use Kodak Tri-X film with D-76 developer at 68 degrees, an optimal temperature; the developing time is ten minutes. The lower the temperature of the developer, the longer the time it takes the film to develop. At 65 degrees it's necessary to develop the film for eleven minutes, nine-and-a-half minutes at 70 degrees, and nine minutes at 72 degrees. Once you choose a film-developing temperature, all the other chemicals must be the same temperature to avoid the film

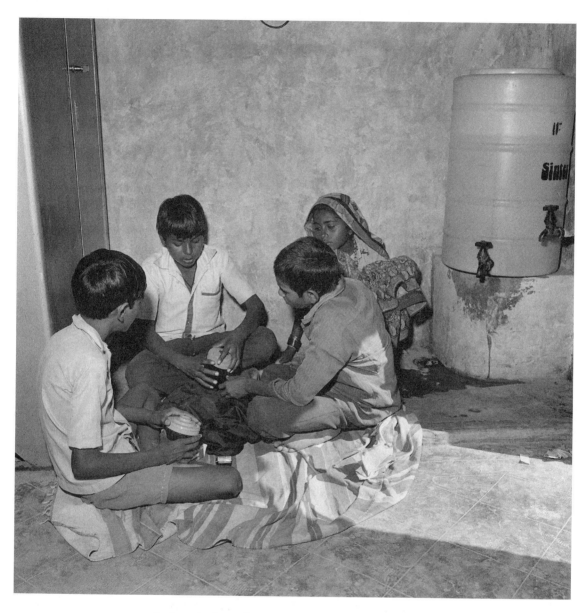

Students developing film
in the darkroom
WENDY EWALD

emulsion cracking—this is called reticulation, and it makes your photograph look like it was printed on cracked linoleum.

When you're ready to start the film-developing process, begin timing and quickly pour the mixed D-76 into the top of the canister. The canisters are made so that liquid can enter, but not light. (Liquid can go around corners, but light cannot.) Bang the tank twice to release air bubbles that could prevent the developer from touching the film. Agitate or rotate the canister for the first minute of developing. Then agitate it for five seconds every thirty seconds.

When the developing time is up, pour the D-76 out of the canister and down the drain; then replace it with stop bath. Stop bath comes in liquid form and should be mixed two ounces to a gallon of water. Agitate for 30 seconds, then pour the stop bath down the drain. The developer will continue to develop the film until it is neutralized by a stop bath. A stop bath is a mild solution of acetic acid (mix two ounces of stop bath with two gallons of water).

The next chemical is called fixer. Fixer removes the unexposed silver so that the film can be viewed in room light. Without this step, the unexposed silver, like the exposed silver, would become dark and erase the image that was just developed. Fixer also comes as a powder; it should be mixed with water at no hotter than 80 degrees Fahrenheit. Fixer should be mixed the same way as the developers, but it makes a gallon of working solution so doesn't have to be diluted before use. Pour in the fixer and agitate for one minute. Then agitate for ten seconds every minute for six minutes. (Read the directions, however; there are different kinds of fixer with different requirements.) You can also recycle the fixer for use when making your prints. Now you can remove the top from the canister.

The fixer must be washed out of the film completely or the image on the film will deteriorate. First wash the film in running water for two minutes. Then pour in a solution of orbit bath, which changes the fixer into a compound that is more easily washed off the film. Orbit bath comes in a liquid concentrate and should be mixed three ounces to one gallon of water. Agitate at fifteen-second intervals for two minutes, then pour the orbit bath out and wash the negatives with running water for an additional five minutes. Finally, dip the negatives into a solution of Photo-flo, which reduces the surface tension of the water on the film so that the water won't leave spots when it dries. Dip your fingers in the Photo-flo and carefully squeegee the film between your fingers. Hang the film up to dry in a clean space. Once the film is dry, cut it into strips of six negatives each and put the strips in protective sleeves.

The Print

We begin with the negatives and the enlarger—which is, in effect, a sort of camera standing on end. Directly above the slot where the negative sits there is a light source. The light shines through the negative and the enlarging lens to make an image on the easel directly underneath the enlarger. If you raise the head of the enlarger—which contains the light, the negative, and the lens—the image becomes larger. If you lower the head, the image becomes smaller.

The enlarger head is positioned to achieve a satisfactory size for the image. Then, like a camera, the enlarging lens must be focused so the image on the easel is sharp. Now the exposure, or the amount of light passing through the negative, must be decided. The amount of light is a function of the brightness of the illumination and the time it stays lit.

The enlarger is hooked up to an electric timer calibrated in seconds, with a maximum setting of sixty seconds. You must set it to a number appropriate for your negative—say, ten seconds. When you set the timer to ten seconds and press the timer button, the enlarger light will automatically turn on for ten seconds.

The brightness of the light is adjusted by the aperture. The aperture is a small hole in the lens that's size can be varied to determine how much light passes through the negative onto the photographic paper. The most commonly used aperture settings have been assigned numbers according to a rather mystifying convention: The larger the number, the smaller the aperture setting. The smallest setting on the lenses of the enlargers we use is 16, the largest 5.6.

Printing the photographs is really the most exciting part of the work for me as a photographer and a teacher. It is now, through a process that seems alchemical, that we finally get to see our pictures.

Chemicals—developer, stop bath, and fixer—must be mixed and poured into 8 x 10 trays. The print developer is Dektol. You will need to make a stock solution of Dektol by mixing a can of powdered Dektol with a bit less than a gallon of water. This stock solution is then diluted one part Dektol to two parts water, or ten ounces of Dektol to twenty ounces of water, at approximately 70 degrees. There is no need to mix the stop bath. You will have mixed the stock solution beforehand so that it can be used straight from the bottle. And the same fixer used to develop your negatives can be used here, too.

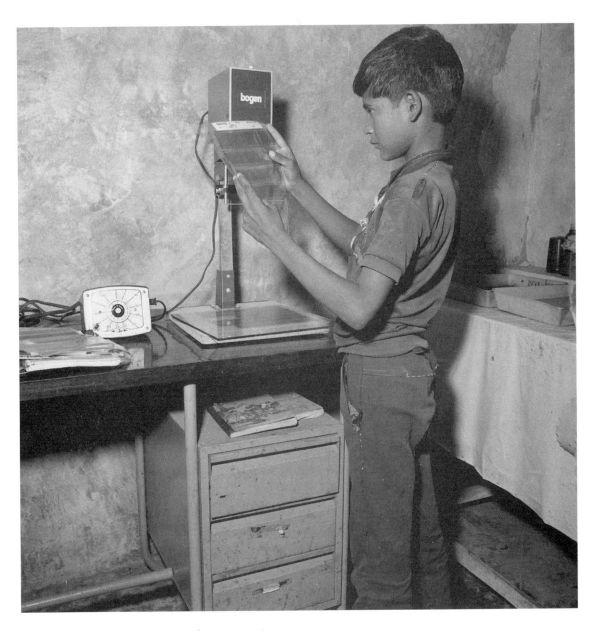

Ramto chosing a negative
to print
WENDY EWALD

The photographic paper is coated with a light-sensitive silver emulsion, just like the film used in the camera. The emulsion reacts with the chemicals; an image emerges. When light touches the emulsion, the silver is transformed. In the developing process, the silver that has been hit by light turns various shades of gray or black. This process reverses the negative's polarity of light and dark and creates a photographic print. In the negative, as we've seen, everything that was white in the real-life subject becomes black, and everything that was black becomes clear. Now, when the light shines through the negative in the enlarger, more light will shine through the clear areas of the negative than the dark areas. When the paper is put in the developer, the clear areas will turn black and the dark areas will remain white. Essentially, the more light that hits the paper, the darker it will be when it's developed.

When the students are printing, all white lights, including the enlarging light (except when making exposures), must be turned off so they do not affect the unexposed photographic paper. In order to be able to see, we use a safelight, which is usually red or amber. Safelights are available in all photo supply shops. In India my students referred to the safelight as "God's bulb" because it reminded them of the red lights placed above ceremonial altars. In a pinch it's possible to make a safelight by covering a low-wattage bulb with red paint, as long as the paint doesn't peel off.

It's always good to make a test to determine if your safelight really is sufficiently dim so the photographic paper isn't contaminated by stray light. With the safelight turned on, take a sheet of photographic paper out of its protective sleeve and put a few coins on it. Let it sit for five minutes, then develop and fix the paper. If the spots where the coins were placed are lighter than the rest of the paper, you know the safelight isn't safe enough. You'll have to move the light farther from the paper or dim it in some way.

It takes the students some time to get used to the dim light. When they do, the darkroom can seem a magical space all their own. In India the students of different castes were able to converse and touch each other away from the watchful eyes of adults. Geeta, a member of the merchant caste, said, "*Harijans* (untouchables) can't come into my house. My father scolds me if I even speak to them. But my father is not here in the darkroom, so I can touch and talk to my friends now."

The Contact Sheet The first step toward making full-sized prints ("enlargements") is to make a contact sheet. A contact sheet is a sheet of photographic paper exposed to the negative sandwich-style, in direct contact with the negatives, so that each frame on a roll of negatives is printed without enlargement—as a series of "thumbnails." It's possible to see all the pictures taken on one roll on a single sheet of 8 x 10 photographic paper. By examining the contact sheet the students can determine which pictures they want to enlarge. If it's difficult for them to read such small images, they can use a plastic loupe or magnifying glass.

The enlarger head must be lifted high enough so that when it's turned on the light will cover the photographic paper. Each contact sheet will need a different amount of light depending on how thin (with little silver) or thick (with more silver) the negatives are. A good place to start is to set the aperture on the enlarger at f16 and set the timer at ten seconds.

After you make sure the enlarger light is off, take out an 8 x 10 sheet of photographic paper and place it under the enlarger with the shiny side up. Arrange the negatives—still in their plastic sleeve—shiny side up, on top of the paper. Put a 9 x 11 piece of glass on top of the negatives. Make sure the negatives don't move after you push the exposure button. After ten seconds, when the light goes off, remove the sheet of paper and put it face down into the developer tray. Be sure the entire sheet is immersed. Agitate the paper gently. If you turn it over after five to ten seconds, you can watch the image emerge. Now the paper is a print. You must leave the print in the developer for ninety seconds, even if it begins to look too dark. If you remove it too soon, the areas that should have been black will be muddy gray. Remove the print with tongs. Let it drip for five seconds before putting it into the stop bath.

The stop bath will immediately stop the print from developing any further and getting darker. Since it is an acid solution, it will neutralize the alkaline solution of the developer. (You'll feel the difference with your fingers.) Agitate the print in the stop bath for thirty seconds. Let it drip for five seconds before moving it to the fixer. After you have agitated the print in the fix for one minute, it is light-safe. You may look at it in the white light, but you must return it to the fix for two more minutes. If your print turns a blue/purple color in the white light, or if it yellows with time, your print hasn't been properly fixed. Either you haven't left it in long enough, or your fix is exhausted. You can use Edwal Hypo Check to make sure your fix is still good.

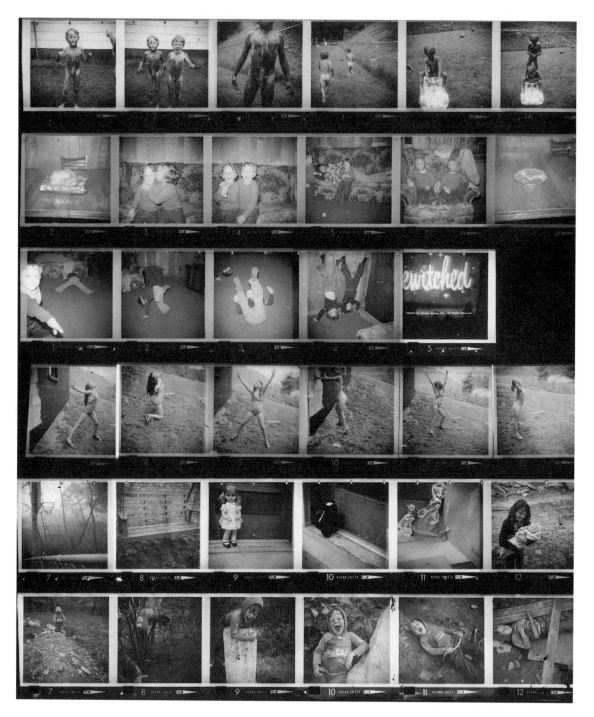

Contact sheet

DENISE DIXON

If the contact sheet is too dark, set the timer for a shorter period—five seconds of light, maybe, instead of ten. If the contact sheet is too light, use more time—twenty seconds. Wash the fixed contact sheet in running water for five minutes. Then squeegee it and hang it up to dry, or dry it on a drying screen.

Once you've made the contact sheet, you can decide which pictures you want to print. It's good to keep all the contact sheets and review them with the students. With a second or third look, they may find more images they'd like to print. It takes a bit of practice to read contact sheets, so don't be afraid to let the students spend time on this. If a student wants to print a negative that is either too light or dark on the contact sheet, check the negative with him to determine if it's possible to make a good print from it. Experience is really the only guide here, but as a general rule, a negative that looks very pale overall, or one that looks densely dark overall, is not going to yield a good print. I'll discourage students from printing a technically poor negative; I want their first experiences with printing to be successful.

The Test Strip Once the student has chosen which negative to print, we'll make a test strip together to determine the amount of light needed to make the best possible print from the negative. A test strip is made of several different exposures from a single negative, and one should be made for each negative. The negative must be placed in the enlarger's negative carrier with the shiny side up. The bottom of the image on the negative (the ground, the subject's feet) should be placed away from the person operating the enlarger; this way, the image projected by the negative onto the easel will be right-side up.

In order to adjust the size and focus of the picture, the student must turn on the enlarger light and open the aperture to its brightest (smallest number) setting. He will be able to see the image projected on the easel where the photographic paper is placed.

By cranking the enlarger head up or down, the student can get the size image he wants. He will then turn the focus knob until the image is sharp and close the aperture down to 8 or 11. (In the course of determining the best aperture setting, he should take into account the brightness of the enlarger bulb—they vary in brightness. He'll need to experiment.) Set the enlarger timer to two seconds. Turn off the enlarger light.

Cut a one-inch strip of photographic paper. Place it on the easel. For this test, you should try to include the subject, or some important areas of

Test strip. Holding my baby.

DENISE DIXON

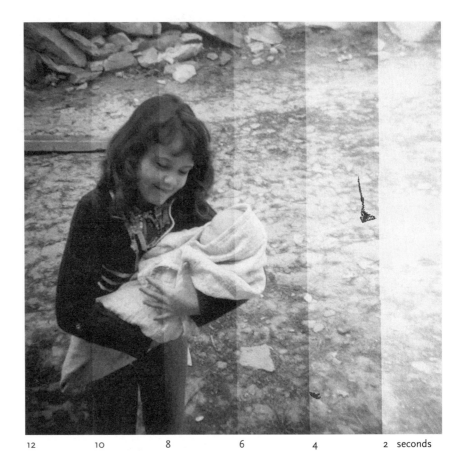

12 10 8 6 4 2 seconds

the picture. With a piece of cardboard, cover all but one end of the strip of paper. Push the timer button, keeping the cardboard steady. When the light goes off, move the cardboard left to expose another section of paper. Again push the timer button. Repeat this sequence four times. The first strip will have been exposed to light for twelve seconds, the next for ten, the next eight, then six, then four, and the last for two seconds

Put the test strip through chemicals, just as you did the contact sheet. After one minute in the fixer, you may take it into the white light. You should see five divisions between the different exposures. The lightest area will be two seconds and the darkest twelve seconds. Pick the area that looks best. You are looking for good highlights; the white areas should have details in them. Shadows should be black but should also contain details.

If the test strip turns out too dark, it was because the enlarger gave it too much light; you must reduce the aperture or the time. If the test strip

Print at eight seconds

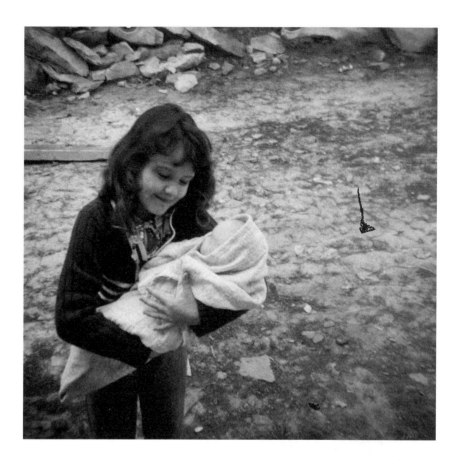

is too light, the image was not exposed long enough, so add some more time or increase the aperture. When you've decided on the correct exposure, you're ready to make a print.

Making Prints Adjust the timer to the time you have determined from the test strip. Make sure to keep the aperture at the same setting as the setting you made the test strips with. Turn on the enlarger light to check that the easel is where you want it to be and that the image is still in focus. Then turn off the light.

Get out a piece of paper and place it on the easel with the shiny side facing up. (Unless we're making prints for exhibition, we usually make 5 x 7 prints with the students. For exhibition we use 8 x 10 paper. In the schools we work with, cost of paper is an issue.) Now press the timer button. Wait until the enlarger light automatically turns off to remove the paper. If you move the paper in the middle of an exposure, the print will be blurred.

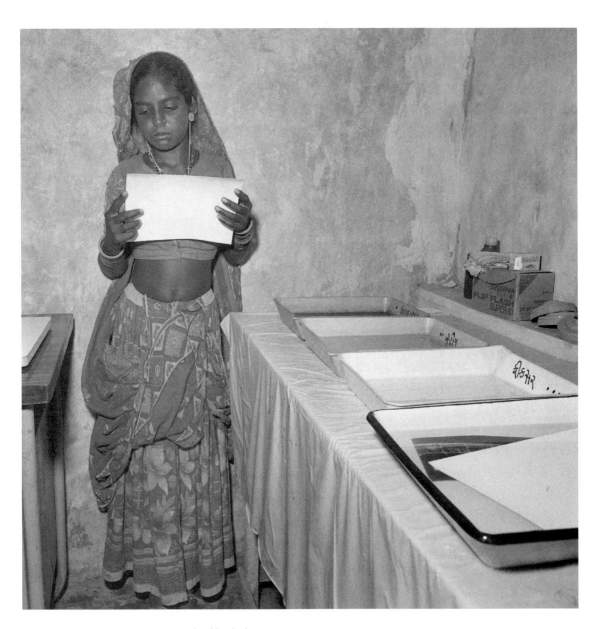

Hansi Jhivabhai looking at
her finished print
WENDY EWALD

Immerse the paper, shiny side down, in the Dektol developer for ninety seconds. Agitate or slowly rock the tray to ensure even development of the print. Remove the paper with tongs and allow it to drip for five seconds before placing it in the stop bath for thirty seconds. Then drain it again before putting it in the fixer for three minutes. After a minute you may want to look at it in the white light to check on the exposure.

You may have to make a few prints at different exposures to get what you want. Finally, wash the print in running water for five minutes to remove all the chemicals. Squeegee it and hang to dry.

These basic instructions do not include the fine points of printing such as contrast control, dodging, burning, and flashing, to name a few. There are fine technical books listed in the bibliography that can help you go further.

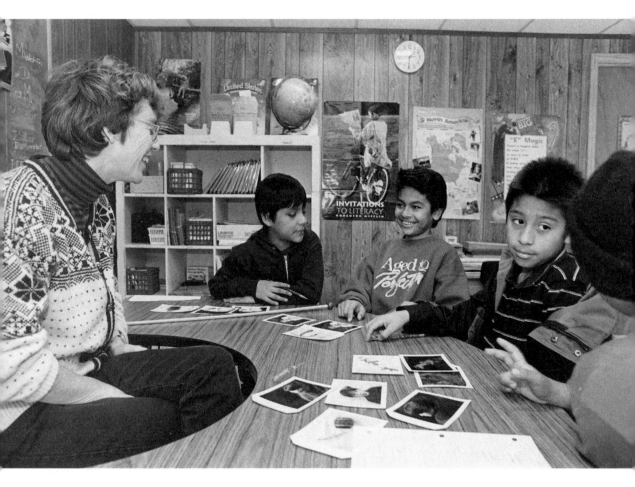

Wendy Ewald and ESL students
discuss their photographs
JULIE STOVALL

Using Photography in the Classroom

Photography offers endless possibilities in the classroom. Teachers can use photography to explore a wide range of issues, investigate many subjects, and engage with students on questions about history and current affairs. And when teachers encourage kids to examine, in photographs and words, what their lives are really about, the teachers themselves are on the way to learning something important about a subject most vital to them—their own students.

Photography can create moments of authentic collaboration between teachers and students, moments when a deeper understanding of the lives of others emerges. "We've all read the news reports and the magazine articles about other people's lives," says Alan Teasley, an administrator in the Durham Public Schools. "But when someone we have a relationship with shows us a picture of his mother and her boyfriend, or the room that he shares with his two brothers, it's different. It's personal in a way we can't deny."

There's little doubt that photography can enhance students' (and teachers') responses to the demands of learning. This chapter addresses how you can find the time and develop your own strategies for integrating the benefits of photography into the requirements of standard curricula.

LTP in the Curriculum

The creation of images is a whole new thing in Durham classrooms. LTP has children engaged in writing about themselves, their families, their dreams, and their communities. It brings a student's life into the classroom not as an object of study, but as a valued source of material for expression. Because children are actually working with their own stories, it values their lives. It can be very powerful when children are allowed to talk about things that are important to them and to have what they say not judged negatively, but accepted.

—ALAN TEASLEY, school administrator, Durham, North Carolina

Lisa Lord teaches the fourth and fifth grades at Club Boulevard Humanities Magnet School in Durham. She's threaded methods learned from LTP through different parts of her curriculum, tying them together. She finds that her students take their photographic work seriously, and that they care

deeply about the results they achieve in their written and photographic por-
traits. For Lisa, the LTP process offers a valuable lesson in how to teach and
how to get to know her kids. "It's *real*," she says, "and it gets kids completely
engaged in writing and thinking. When you give kids choices about what
to write, it's theirs. They feel pride, and it raises their self-esteem."

Photography does the same thing. When children share their photo-
graphs or talk about how they took an image or what is in it, they speak
with authority. Everyone treats the student as an author, as a person who
has something to say and something to show. The kids experience them-
selves as writers, as photographers. "And," says Lisa, "they're *good*."

She adds that LTP pushes her to make sure that her curriculum is not
just something out of a textbook or dictated by the state. As a teacher, she's
fully aware of what the state objectives are, and she understands how teach-
ers get lured into thinking that if a subject is in the textbook, in the state
curriculum, or on the state test, then it has more value than something they
initiate themselves. But she knows that she can better achieve state objec-
tives with a project that is more authentic, more closely tied to a child's life.
"A kid realizes, 'This is not just worksheet #74; this is about me.'"

Lisa understands that the ways individual teachers implement the
curriculum are very often judged by asking, "What effect will this have on
end-of-grade test scores?" "I couldn't spend very much time on a project
that didn't have a positive effect on test scores," she says. "This does."

How LTP positively affects test scores is a subtle question. "Finding
ways to elicit the important things that kids have to say is rarely considered
the essential part of teaching," Lisa says. "We tend to skim the surface of
a million topics, and kids don't get very much. With LTP you get *into* a
project; you're not flitting from little thing to little thing. Even just simple
things, like following the directions—How do you develop a picture?
What image goes first, and what's second?—these things encourage
sequential and methodical reasoning as well as expressive writing and
critical thinking."

It's clear that LTP really does help motivate the kids to write. "When
I first started," Lisa says, "I thought of it as a nice project that we might
want to do a couple of times a year. What I've found is that it's easy to come
up with a new photography project that makes sense with the rest of your
curriculum. I can see spending the whole year working a photography com-
ponent into what we are reading, writing, and learning."

My Community
by Dorrian Roberts

In my community there is a police department. On the door there are a few wanted signs. Next there is a fire department . The fire department looks small on the outside but on the inside it's pretty big. The police and the fire department are important because if a house catches on fire the fire fighters won't have to go far. Also, if someone gets robbed the police can catch the robber easy.

There is a car wash a couple blocks from my house. Some people vacuum their car before they get their car washed. There are 10 lanes where you can wash your car. I like going there because I get to go across the street to McDonald's while my mom washes the car.

My Community
DORRIAN ROBERTS

Years ago, in the early days of Literacy through Photography, I started out working with children from two classrooms in a two-week artist's workshop. Now LTP has grown to the point where teachers participate in introductory and advanced workshops offered every summer. Some of the workshops are specialized, such as those for English-as-a-Second-Language teachers, and those for teachers interested in learning the curatorial process. We also offer a course at Duke University that trains undergraduates as volunteers in public school LTP classrooms. We put the teachers and the college students through the same process as the children. They shoot pictures according to methods developed by LTP, work in darkrooms, and connect their own writing to the photographs they take. At a recent workshop for ESL teachers, we asked everyone to draw a "memory map" of a place that seemed inaccessible or forbidden to them as a child. We asked them to write about this place based on the drawing they'd made and their memories of it. Then we asked them to think about a site in the community where they currently lived. We told them to approach it as though they were new to the community and seeing it for the very first time. With this orientation, we sent them out to photograph the site.

The teachers were asked to talk about the photographs they'd taken and share their experiences of photographing in a place strange to them, where they might be considered outsiders. Many of them spoke of being stopped and questioned when they raised the camera to their eye. The result was that the sites became, in effect, off-limits, inaccessible to them. This exercise—especially the experience of being perceived as outsiders—made the teachers think deeply about how they, as educated adults and, in this case, white people, were accustomed to being treated. Putting themselves in an unfamiliar place and trying to take pictures gave these teachers a better understanding of the lives of their students—who are "outsiders" in a new country.

Through this kind of intense, creative experience, teachers learn the mechanics of the process, and they begin to think about how children see. They are then in a position to connect this new knowledge to their own curricular needs and objectives.

In addition to developing a core curriculum based on topics like self-portraiture and community, LTP in Durham has functioned as a lab for creating new projects. While working with Lisa and other teachers, we

keep asking basic questions: How does photography fit into other areas of the curriculum that teachers are required to follow? What are its different uses? How can this process help kids better understand what they are learning in school? How might teachers use these methods in their own classrooms as a part of their curricula? We keep asking and asking. And we begin to discover ways to expand and develop new uses for photography in the classroom. What follows is a sampling of new projects I and others have created with teachers.

Art Art teachers have adapted LTP in a variety of interesting ways, particularly with respect to what children produce and how their work is displayed.

For the past few years we've invited nationally known artists to create their own work in LTP classrooms. In hindsight, starting this artist-in-residence program seems obvious, because LTP can be linked most readily to the arts curriculum.

Robert Hunter, a middle-school art teacher in Durham, uses LTP to introduce topics that are relevant to his students' lives. One year his class produced folding accordion photo-books to display their photographs and writing. The following year, we invited artist David Chung to Durham, and he worked with Robert's students on arts constructions to transform the way they presented and saw their images. David and Robert decided to combine the children's photography with the construction of a Korean folding screen. The children decided at the outset to approach the entire project with the image of a tree as the guiding symbolic principle. The students made photographs from their own lives and cut them into pieces to create a tree-like photo-collage. For the artist, David Chung, it was intriguing to find ways to incorporate the kids' ideas into a traditional Korean art form. For the teacher, Robert Hunter, it was a chance to open up the learning process while covering a multicultural unit required by the curriculum.

"Multiculturalism," Hunter explains, "is understood more thoroughly through projects that deal with another culture's history. Our learning process started by reviewing the history of images from Korean culture— the idea of the screen itself, the kind of images one ordinarily sees on a screen. The students went on to brainstorm about the images they wanted to create. After selecting their images for each panel, they took photographs to create photo-collages. The kids loved being able to work on a large surface and watch as these simple designs became an intricate mosaic of color

photographs. Transforming photographs of their lives into the symbol they had selected for use in the panes of a traditional Korean folding screen represented the multicultural aspect of our class and work."

Language

Language can be an explosive topic in schools, as evidenced by the heated debates about bilingual education and the use of standard versus non-standard English. Photography, for its part, has proved to be a surprisingly useful tool in untangling language issues.

THE ALPHABET
PROJECTS

Durham's Hispanic population has grown exponentially in recent years, and one day I approached Emelia DeCroix, an English-as-a-Second-Language teacher, about creating an LTP project that used the Spanish alphabet as a way of validating the Latino children's native language—while they were

learning English. (Among the many things we learned was that the Alphabet Project, as this experiment came to be known, turned out to be portable from one language to another.)

The students began by selecting words that were meaningful to them in their everyday Spanish vocabulary. Together we collated and arranged the word lists so that each letter of the alphabet was linked to a word starting with that letter. Some of the children brought items from home whose names were on the list of words that we planned to photograph for the project. The meanings of the more abstract words were imaginatively acted out by the students in front of the camera. While I was the person behind the camera, the students created the image itself.

Each photograph was taken with a large-format Polaroid camera, which produces a negative as well as a positive print. After the negatives

From the *Spanish Alphabet* (left)
WENDY EWALD WITH ESL STUDENTS AT BETHESDA ELEMENTARY SCHOOL

From the *African American Alphabet* (below)
WENDY EWALD WITH STUDENTS AT CENTRAL INTERMEDIATE SCHOOL

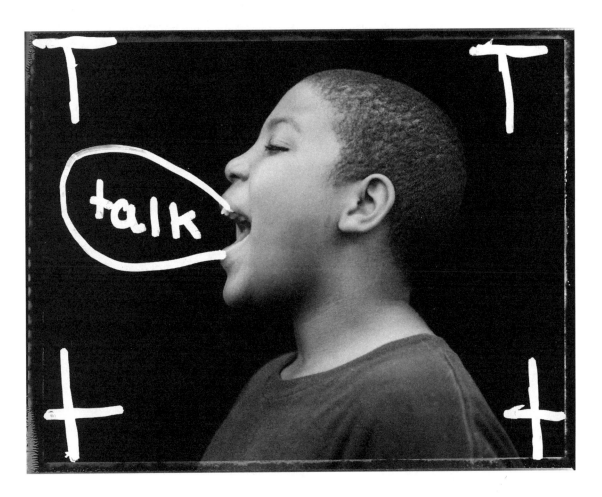

were washed and dried, the children drew or scratched letters and words on the negatives.

The not-so-hidden agenda of this project (and its playfulness as well) was to tap into and honor the children's native culture. It turned out that by embarking on language study from the vantage point of their mother tongue, the students made an easier transition to learning English vocabulary. The students were also very excited about working on a visual project about their language. They talked about how the English-speaking children were mistrustful of them when they spoke to each other in Spanish, and they were happy to share their language with them.

Educators, parents, teachers, linguists, politicians are all engaged in debates about how language is used by young people.

Recently I collaborated on an African American alphabet project with Central Intermediate School in Cleveland and the Cleveland Center for Contemporary Art. Central Intermediate School, which dates from the 1920s and shows many signs of hard use, had no money for supplies. The Cleveland Center for Contemporary Art was looking to expand its work in the community, so they invited me to do a project with students at Central.

Here was an opportunity to let children, whose language adults argued so heatedly about, explain their way of understanding and using language. The children at Central Intermediate School had a lot to tell me about their experiences with the language of home and the language of school. The language they used at home, they said, was more their "own" language.

When I asked them to read out loud some dialogue sequences from a novel by the powerful African American writer John Edgar Wideman, they started reading Wideman's words as they would any book in a classroom, in a flat, monotonous way. But their boredom did not last long. Soon they began to feel Wideman's language, to recognize in his words, so eloquently put on paper, the sounds they experienced in their own communities. The kids came alive in their reading, delivering the words forcefully, dramatically. It was wonderful to be present at this transformation. (I emphasize that the kids read *dialogue* from the novel; I don't think the exercise would have worked nearly as well if I'd given them descriptive passages to read.)

These readings were a way to prepare the students to create an alphabet based on their own words. Together we made up a list of words they

used in their home communities but not in school. For example, for the letter *C* they offered "cheesing," which means smiling for the camera. For these students, the African American alphabet project legitimized use of their own language in a school context, if only for a time. For the Central teachers, most of whom were white, it came as a revelation to discover that they didn't know their students' everyday vocabulary. The teachers gained an appreciation for the complexity and inventiveness of African American language and developed a deeper understanding of the communities where their students lived.

Social Studies

THE BLACK
SELF/WHITE SELF
PROJECT

When I first started working in Durham in 1989, there were two separate school systems, a city system that was predominantly African American and a county system that was mostly white. The two systems had different school boards and very different economic bases. There were endless discussions within the communities and between the school systems as to whether the two systems should be merged.

Working primarily in the inner-city schools, I was struck by how often our discussions about community issues would center on race. The kids had a lot to say about race, so I pursued the subject. My middle-school students had very specific ideas; they were acutely perceptive about the differences between blacks and whites and variations in skin colors. The African American kids often spoke about things that happened to them during their interactions with white people, about times when they felt that whites were afraid of touching them, or harbored bizarre suspicions about them. In the course of these conversations, I came to realize how important it was to look at Durham and its schools in terms of race.

A number of my students had been sent from large northern cities to live with relatives in what their parents perceived as a safer environment in Durham. These students were articulate about the differences between Durham and the cities they came from. Some told me that in the North, they were able to have mixed-race groups of friends, but in the South they found "mixing" hardly possible. In Durham they felt pressure to be separate.

There was also a lack of communication between white and black teachers in the teacher-training workshops I was conducting. They often sat in self-segregated groups, and the white teachers tended to dominate the conversations.

At this same time, as it happened, I was planning an extended trip to

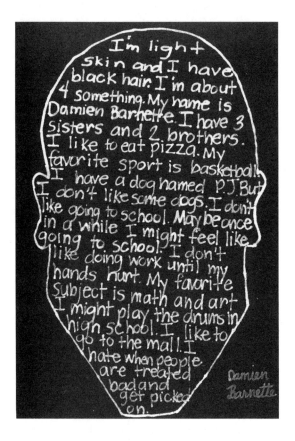
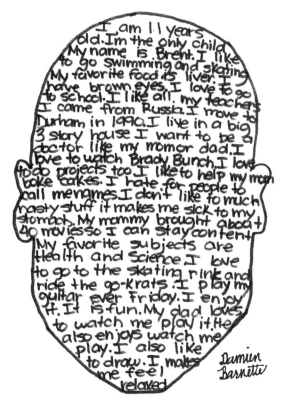

Black Self and *White Self*
DAMIEN BARNETTE

South Africa and my research led me to photographs documenting that country's system of apartheid. I asked some of the teachers in North Carolina to write about a photograph showing a confrontation between Afrikaner soldiers and black African men. Some of the African American teachers attending the workshop wrote very powerful pieces in reaction to the photograph. One wrote about her painful memories of growing up in a white neighborhood where her family were the first black residents. Another woman wrote about a civil rights march she had taken part in. For the African American teachers, sharing these stories was an affirmation of sorts; it tapped into a compelling but unspoken sense of responsibility to share these kinds of experiences and memories with their students. For the white teachers, this conversation opened their eyes and let them know their colleagues better.

Getting the topic of race on the table in the schools led me to consider the possibility of using photography as a way to grapple with the difficult transformation that took place when Durham's county and city schools

finally merged the two school systems. Photography, it seemed to me, might be a way to open discussions about race between teachers and students, blacks and whites, city and county. As things stood, these groups had little, if any, contact with one another.

I began working with two teachers, Cathy Fine, a white elementary school teacher, and Robert Hunter, an African American who teaches middle-school students. We decided to explore their students' perceptions of race by means of written and photographic portraits. We asked students to write self-portraits depicting themselves as they were—whites as whites, blacks as blacks. We encouraged them to be as detailed as possible. Then we asked them to imagine themselves as members of the other race and to write detailed self-portraits of their imaginary selves.

In preparation for taking pictures, we encouraged the students to bring in props from home and think about how they wanted to pose. Once the portraits were shot and the negatives produced (using Polaroid positive/negative film), we invited them to use markers and etching tools to alter the negatives with details or words.

I was hoping for some expressive results, and I was not disappointed; the children's writing and imagery were strong and revealing. Vast differences existed between the two selves chosen by each child. One African American child said that if he were white, he would be "normal." Many of the African American children put their dreams and fantasies into their white selves. Michael Greene, for example, posed as an angel and drew wings sprouting out of his back.

The project raised uncomfortable issues for the teachers. Many reported that as a result of doing the Black Self/White Self Project they went on to address these issues in their classrooms in a more sensitive and thoughtful way. "The project is an excellent tool," Robert says, "for helping kids venture not just into imagination but into fact-finding, into analyzing what is real in their world and what is not so real."

Black Self/White Self lends itself for use in the history or social studies curriculum when a class is studying contemporary issues of race and when teachers are looking for ways to stimulate students to think about differences between cultures and historical eras.

It is also a compelling example of how an LTP project can draw on kids' personal experiences and still be an effective part of a curriculum.

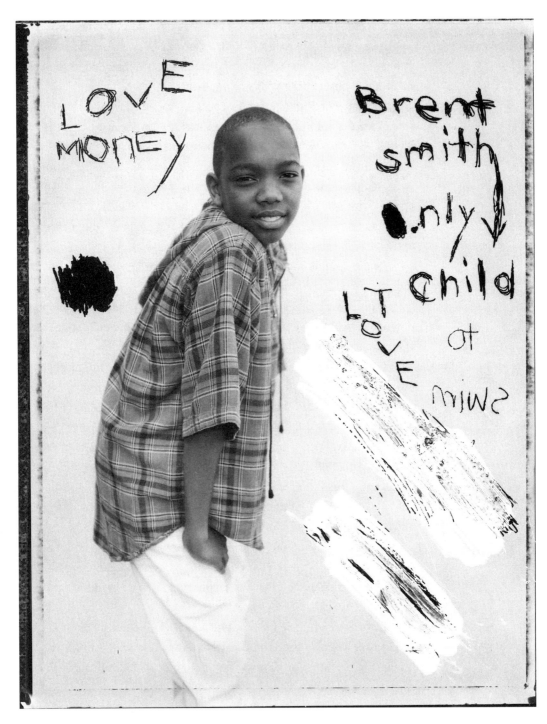

White Self

WENDY EWALD AND DAMIEN BARNETTE

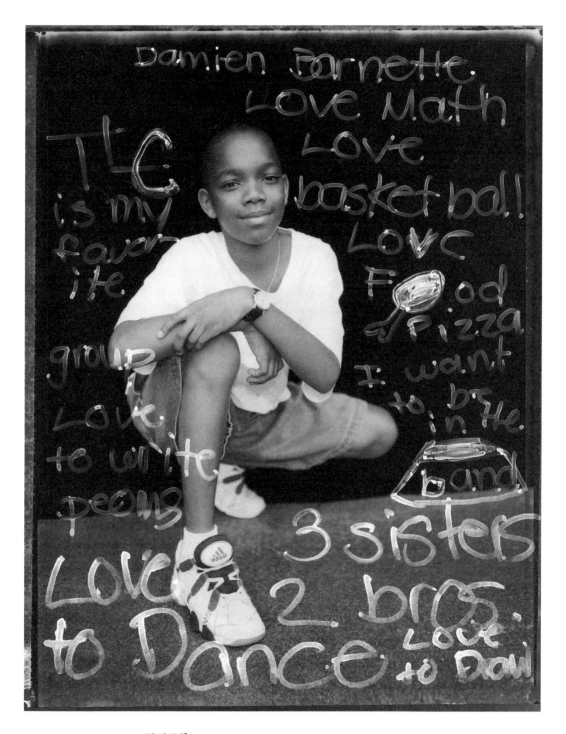

Black Self
WENDY EWALD AND DAMIEN BARNETTE

The Holocaust Project

There is a sense in which teaching photography to children is about developing empathy in adults, about learning to see the world the way children see it. As Lisa Delpit, a noted professor of education, put it, "Until we can see the world as others see it, all the educational reforms in the world will come to naught."

I had the opportunity to deal with this issue directly when I was invited, along with seven other artists, to create a work drawing on the huge archives of the American Jewish Joint Distribution Committee. In their records I read case studies of Jewish children who had been relocated after the liberation of the concentration camps. Each file included a photograph of the child, along with a concise history of the child's experience of arrest, imprisonment, and relocation. After weeks of studying the pictures and stories of children who had endured such terrible experiences fifty years ago, it occurred to me that it might be possible to collaborate with some of my Durham students on this project, many of whom were now the same age as the children in the files. Lisa Lord and Robert Hunter—teachers who have worked with me consistently over the years—volunteered to work with me in their classrooms.

I distributed the case studies to Lisa's elementary school children and Robert's middle-school social studies class. The "subject" fit in with existing school themes (human rights at the elementary level and international learning at the middle school), so each teacher was able to explore such a sensitive topic in their classrooms. And it was a way to acknowledge the life experiences and maturity that students could bring to the project. We suspected that for some children, their own experiences of prejudice might resonate with these stories of Jewish children during the Holocaust.

As a way of connecting the Durham students to these stories, we assigned each of them a child from the archives. We asked them to immerse themselves in the facts of the child's life. They also read about the Holocaust, engaged in classroom discussions, and did some writing. They visited a synagogue and saw movies about World War II. Given the age difference of elementary and middle-school students, we carried out the project somewhat differently in the two schools. For instance, we chose to omit certain images with the younger classes.

After this preparation, the students wrote three narratives—one from the perspective of "their" Jewish child, a second from the perspective of a bystander or witness to his or her experience, and a third from the

perspective of a child whose parents were Nazi sympathizers. Finally, the students performed one of their three written pieces while I videotaped the performance.

It was stunning to see children in North Carolina, fifty years after the liberation of the concentration camps, take on the personae of these other children. It was unsettling, too, the way they intuitively captured details to create their own interpretation of a historical portrait.

Patrick Whitely watching his performance for the Holocaust project
PETE MAUNEY

Patrick Whitley was one of the participants in the Holocaust Project from Lisa's class. Patrick, a child in constant motion, was a very smart boy who had a hard time concentrating on his schoolwork. The first inkling of how significant this project might be for him came just after the students had read the case histories. Lisa paired her students up and asked them to interview each other about the children whose lives they'd been assigned to research. Most of the kids asked predictable questions—"How old was the child in the case study? Where did she live?"

Patrick, however, posed his questions very personally, as if actually addressing the child his partner had been studying, speaking as a Jewish child talking with his contemporary. "How old are *you?*" he asked. "Where do *you* live?"

When the time came for Patrick to perform one of his narratives for our video camera, he turned up wearing a striped shirt, echoing the prison stripes worn by Joseph Shleifstein, the child whose role he had assumed. Perhaps Patrick's most astonishing accomplishment was the way he, as

someone who had a hard time keeping still, was able to imagine what it must have been like for Joseph to keep still during the two years he spent keeping himself hidden in a concentration camp.

The connections this project engendered did not stop with Patrick's immersion in a forgotten historical character. Joseph Shleifstein, the survivor Patrick portrayed, relocated to New York City shortly after his liberation from Buchenwald, and is now a retired father of two children of his own. Mr. Shleifstein had never talked about his experiences of the Holocaust but had just seen Roberto Benigni's *Life Is Beautiful,* a film about a young child who'd also survived Buchenwald, when he went to see the exhibition mounted by the American Jewish Joint Distribution Committee. He recognized the picture of himself as a child in prison uniform and was deeply moved by Patrick's interpretation of his experience.

Some children used their case studies to mirror contemporary racial tensions. Jessie Franks, an African American middle-school boy, wrote a rap in response to what he'd learned about the Holocaust:

> Hold up—drop this crap, get focused on my rap.
> Nazis, they tried to shoot me.
> It's all about Adolf Hitler, a mad evil killer . . .
> Nazis pulling the trigger . . .
> I'm glad I wasn't the nigger.
> Adolf Hitler committed a crime
> That caused him to lose his mind.
> Spoiled like rotten milk, wearing black and blue silk,
> Buried six feet under, starved because of hunger.
> Hitler is a red devil—would you step to his level?
> Boom! You see what I mean?
> Have you dreamed it? Have you seen it?
> His eyes are red, now Jews are dead.
> You can't change the past, but you can study it in class.
> The Berlin Wall of Germany was destroyed right in front of me.
> I'm all alone, my parents dead and gone.
> Hold up! Wait one minute, let me finish my sentence.
> He tricked you into his trap, now you getting focused with my rap.
> It's like blacks and whites, always getting into fights.
> People will always have their memories from the past century.

LTP and Special Education Students

For most children, especially those who seem to be without a secure place in their classrooms, learning photography can be helpful in building self-esteem and self-confidence. Making photographs and writing about them offers a safe haven where kids can describe the realities of their lives, deal with some of their pressing problems, and articulate their hopes and fears. Behaviorally and emotionally handicapped students as well as kids deemed "at risk" respond unusually well to photography and writing when they are taught in ways that touch close to home.

As a new teacher at a school for behaviorally and emotionally handicapped students, Dave DeVito found teaching photography a tremendous draw for children who'd experienced little success in school. The group of young people Dave worked with had a mix of special needs. Some were mentally handicapped; one was a diagnosed schizophrenic; a few others had severe attention deficit hyperactivity disorder; many had been held back repeatedly. Dave's students viewed photography as a special privilege and a novel experience. His kids got very interested in the process and this, Dave believes, helped them become more interested in the rest of school.

Many of Dave's students had outbursts, but most of them took some responsibility for their behavior. One kid, however, was a particular challenge. He never accepted any accountability, and Dave came to feel that he just might never "grow up." The boy had difficulty reading and never wrote a word. He was in and out of school, and because he missed so many days, failed repeatedly. He did, however, show up for photography and immersed himself enthusiastically in picture taking. (He was also good at basketball.)

Dave noticed that using Polaroid cameras worked well with his special-needs students because the kids got immediate feedback; they could see right away the results of their planning and effort. When he asked his students to take self-portraits, the "problem boy," who loved basketball, wanted to shoot Polaroids of himself doing a slam dunk. He planned his pictures in detail and figured out how to get the shot he wanted by standing on a ladder over the net.

"He did it right," Dave recalls. His most difficult student wound up shooting the most complex, interesting, and well-planned photographs of any of the special-needs children. This student never missed Dave's class, stayed with it throughout, and carried out the process with interest, creativity, and excellence.

If LTP offers a means for children in regular classrooms to take a

project from start to finish and to put their own visions into words and images, it seems to offer even more to children with special needs. It may be just the kind of hook that allows special-needs children to experience success in a classroom setting.

Setting Up a Program in a School

Over the years the LTP program has benefited from the unwavering support in Durham of one or two central office administrators, several energetic principals, a growing and determined group of teachers, and many parents who see the program enriching their children's learning. We urge anyone who is thinking about setting up a similar program in a school system to gain the interest of various stakeholders—teachers, principals, administrators, and parents—and approach the task as a team effort.

Once you decide to go ahead, there are ways to create a program that fits your school's needs and resources. For example, it is possible to do Literacy through Photography without a darkroom. In such cases the children shoot the pictures, and the teacher sends the film out to be developed. But in general, teachers and I find that there are advantages to engaging everyone, children and teachers alike, in the darkroom process.

Learning to develop and print film lets children master a complex process that many adults cannot do. Children draw on their own capabilities to develop their individual skills and vision. Time spent in the darkroom also encourages children to be responsible and cooperate with one another. You'll notice how working in the darkroom breaks down barriers between children. By working together and helping each other master all the steps in photography, children build relationships. The children also learn that other kids, even the ones who aren't the smartest or the best readers, may have surprising talent when it comes to developing and printing photographs.

You will need extra help and the time commitment is considerable, but working together in a darkroom can be a model of cooperative hands-on learning.

Setting a Schedule for the School Day

We recommend devoting at least four hours a week to a photography and writing project. Specifying how many weeks the project should take and carving out the time is often the greatest hurdle. Some teachers choose to carry out the project over the span of a semester, covering each of the five

LTP themes (self-portrait, family, community, picture story, and dreams) during this time. Others devote fewer weeks, scheduling the themes in segments over the course of the year. The possibilities for structuring time will vary greatly according to how the school is scheduled at all levels. In middle school, where children change classes and teachers do not have students all day, there is less flexibility. You will need to find ways to fit LTP into the curriculum. The middle-school teachers we work with are inventive when it comes to finding time to devote to LTP. One strategy is to partner with a teacher in a different curriculum area to do a project. This kind of collaboration can expand the amount of available time.

Teachers working as a team can use longer blocks of time. Or they can split the class so that half the students are in the classroom while the rest are in the darkroom. For example, Chip Moore and Judy Alford, two fine teachers we worked with in the early days of LTP, taught a combined class of twenty middle-school students. Chip was the language arts and social studies teacher; Judy taught math and science.

Some teachers save time by doing the photography and writing assignments and sending the film out to be developed. There are, of course, schools that schedule photography as an after-school enrichment activity, though most teachers see benefits in integrating the process into their curricula.

Katja V. Stevens is a middle-school teacher and very experienced in adapting LTP to different classroom situations. With a group of children who are weak in writing, LTP offers a way to teach a particular skill, and also a way, as Katja puts it, to "con" the students into liking to write.

She uses photography to support whatever type of writing she asks students to do. While she finds the linking of photography to writing particularly useful with weaker writers, she also values LTP as a way to stretch the creativity of her more advanced writers. Katja uses photography when she is preparing her students for a not-very-appealing writing assignment, such as learning to write an expository essay. For instance, Katja may begin by engaging her students in exploring the theme of family. She will ask them first to take photos of their families, then use the photos as the basis for writing about a favorite family member, explaining in great detail the feelings suggested by the pictures.

Katja also finds innovative ways to expand on LTP methods in teaching

social studies. North Carolina's standard course of study requires seventh-graders to study the continents of Africa and Asia. Katja asks her students to choose a country on either continent and select some important aspects of that country to focus on, such as food, religion, or schooling. The goal is to compare and contrast the country's culture with that of the United States.

From *National Geographic* magazines or CD ROMs, the children search for photographs illustrating the themes they've selected. They then take photographs of the same subjects in their own communities. A student might find photographs of vegetarian dishes from Asia or Africa, then take photographs of the meat department in her local grocery story, showing the differences in staple foods eaten in these two areas of the world. The class would then put together large posters of photographs, images, and writing that addressed the differences and similarities uncovered by the project.

With her advanced class, Katja carried out a dream project. The class had a long discussion about what a dream is—how we think of dreams as goals and aspirations, or as fantasies or nightmares. She asked the children to sketch out the visual components of a dream according to one of these categories. The kids brought props from home and used large-format Polaroid cameras to take staged images of dreams. Katja asked them to write, in prose or poetry, about the meanings behind the photographs. They compiled their pictures and writings into a book about dreams.

Time and scheduling are always big issues for teachers: how to juggle all the elements—taking pictures, writing, developing, printing, and exhibiting—given LTP's intensive time demands. A project takes organization, flexibility, and focus to carry out along with other classroom duties. Having a volunteer or intern, of course, is very helpful. I've found it useful to designate this person as "coteacher"—to legitimize her place in the classroom and in the eyes of the students, especially if the volunteer is young.

Katja Stevens also finds that an LTP project provides her with focused access to students. While some of her students are in the darkroom, there is an opportunity to work on the details of writing with the smaller group left in the classroom.

Katja created a detailed lesson plan for LTP's self-portrait assignment that illustrates how a teacher can adapt LTP for her classroom.

The Self-Portrait

OBJECTIVE: Students will explore making self-portraits through images and words.

TIME: One 18-week semester, approximately twice a week for an 86-minute class period.

MATERIALS: Sample slides of self-portrait images, slide projector, plain paper, cameras, darkroom equipment needed for processing of negatives and development of prints, any other materials needed for final product.

1. INTRODUCTION TO THE SELF-PORTRAIT

a. Writing exercise. Students spend 10 minutes writing anything that comes to mind about themselves. Key questions to ask: What words would you use to describe yourself? Who are you?

b. Share writing exercises with class and discuss.

c. What is a self-portrait? What are the defining elements of a portrait (facial expression, posture, background, clothing, angle)?

d. Look at photographic portraits as a way of beginning to look at the elements of a self-portrait. What can we say about a certain person based on his or her portrait?

e. After looking at several sample slides, students write a short character sketch of people in photographs.

2. SELF-PORTRAIT

a. List 12 things/people that are part of your self-portrait. Share lists and discuss.

b. Identify shared features (friends, family, relations, experiences, likes/dislikes, physical characteristics, emotions).

c. Have students fold a piece of plain paper into 12 boxes (one for each photograph) and make sketches of the photographs they will take as part of their self-portrait, describing angles and other pertinent information.

3. REVIEW HOW TO USE THE CAMERA

4. PROCESSING AND DEVELOPING

a. Schedule volunteer intern to assist in darkroom

b. While some students are in darkroom, class lesson continues as planned.

5. WRITING AND FINAL PRODUCT

a. Have students write about their self-portraits, using poetry, the discursive essay, or creative writing. (In North Carolina the seventh-grade curriculum emphasizes descriptive, clarification, and point-of-view writing, all of which can be applied to this LTP writing assignment.)

b. Have students combine their writing and photography to create a finished project (posters, 'zines, slide shows).

The Details

• LEADERSHIP It's a good idea to designate a lead teacher to oversee the darkroom equipment, handle maintenance and supplies, and supervise the project.

• EQUIPMENT Each school needs to purchase cameras and establish a system for their care, maintenance, storage, and distribution. Cameras do get lost or broken. Teachers need to determine how to handle the inevitable shrinkage in their inventory of working equipment. It helps to get cameras with extended warranties.

• PERMISSIONS At the start of the project, teachers need to send permission forms home with students, to be signed by their parents and returned. This is a very important step. The letter informs parents that their children will be taking photographs, and it encourages responsibility and accountability on the part of the students.

• SHARING Teachers often assign one camera to two children and ask them to share a roll of film. Each child takes twelve pictures, or half of the 24-exposure roll of black-and-white film. Teachers usually allow students at least two to three days with the camera to take their photographs.

• DEVELOPING Developing film with a group of children takes a lot of time. Each developing tank holds two rolls of film. This means, when students share a roll, that four students' images can be developed in one tank. If you have five tanks, twenty students' film can be developed at one time.

• PRINTING With three to five enlargers available, teachers can assign one or two children to each enlarger to print their photographs from the negatives. When printing, children are making important creative decisions; they are selecting images and making careful adjustments to achieve good-quality prints. Printing requires time for the experimentation and mistakes that precede mastery. A class of twenty-five students usually needs three to four weeks to get through this process of making one or two prints each.

• FINDING ASSISTANTS We recruit and train volunteers (including parents) from the community to work in the darkroom with the kids and LTP teachers. Colleges are a great source for student volunteers; LTP in Durham draws from neighboring universities. Teachers can also seek help from their school volunteer program, local volunteer centers, and parents.

Displaying Children's Work

We've had some very authentic work, great children's work, that occasionally principals did not want displayed at the local mall because they thought other people would look at this work and judge them harshly. It's not an issue of censorship as much as it is a question of who owns the expression and to what use is it put? When it is out there in the public sphere, there's no control over people's responses. This, of course, is very real for an adult who publishes a book, but, for a ten-year-old, the school has to act as a kind of protector. This is not an issue we take lightly. When a principal or someone else objects, part of our liberal selves says, "How dare you try and censor a child?" But at the same time, we have to acknowledge there is an argument to be made. For example, an experienced African American principal showed concern about how poor African American children's written work that was not grammatically correct or photographic work that displayed harsh living conditions would be perceived. She was afraid that people would think the children were somehow less because they were poor, that it would reinforce a certain stereotype.

—ALAN TEASLEY, school administrator, Durham, North Carolina

The teachers we've worked with have experimented with a variety of ways to present children's work, from posters to books to 'zines. The most common and inexpensive way to display children's images and writing remains a large piece of poster board. The students each have a piece of poster board. They choose its color and select the photographs they want to mount on it. They select from their written texts to decorate or work counterpoint to their images. Making a display offers students the opportunity to critique, edit, shape, and refine their work in keeping with their own interests and creative impulses. It's fun for them and it encourages sharing.

In Katja Stevens' middle-school language-arts class, the students experimented by using collage and assemblage techniques to present their self-portraits in "'zine" form. Lisa Lord's elementary class collaborated with photographer Alex Harris and handmade-book artist Robert Shreefter to create a vibrant magazine of photographs and writings. The important thing is to be expansive in encouraging children to imagine and create exciting formats for their work.

Public exhibitions validate the children's efforts, but they can also provoke controversy. It's not unusual for people from the school or the

'Zine

WHITNEY MARKS

community at large to be shocked by children's realities and fantasies. For many adults, this candor can be upsetting. There are times when the children's language does not meet community or school standards. There are times when certain images seem to confirm objectionable stereotypes, and other times when the images challenge conventional wisdom.

When I was working in a multi-ethnic school in Texas, a national TV news organization broadcast a feature story on the children's work. The program showed some of their photographs while a narrator intoned, "Their lives are touched by violence."

One of the images that was shown was a young girl's picture of her brother with a gun to his head. Although disturbing, the photograph was an authentic rendering of something real in this child's life.

The principal of the school was furious about the airing of this photograph, and she feared the public's reaction. Interestingly, the teacher whose classroom the work was done in, as well as the kids themselves, wrote me a letter saying that while they understood the principal's concern, they felt there was no problem.

The question of how much to edit or refine the work is always a challenge. What does it mean to enable children's expression? What do we lose by editing out the errors that children inevitably make in their writings? How much of their voice do we lose? What do we gain?

The question of presentation, of how an image will be perceived by a public audience, is crucial when doing this kind of work, and it's important to keep it in mind when you talk with your students about their work.

You'll need to be prepared to address such concerns, to recognize that the standards by which your students' work is judged will vary from venue to venue.

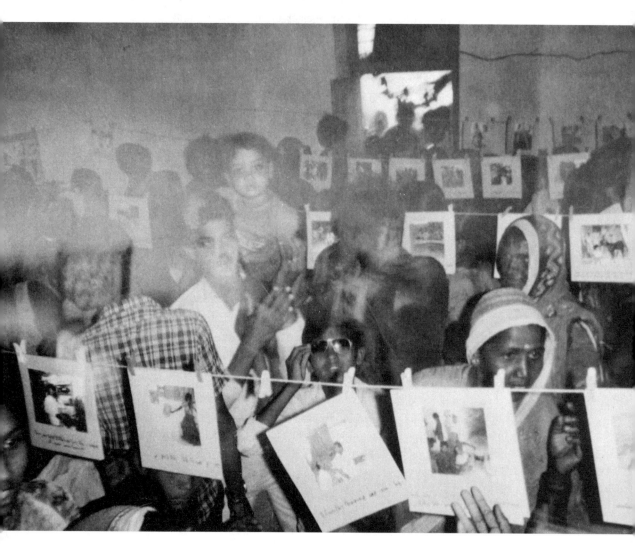

Exhibition opening, India

KALU RUPSINGH

Using Photography in Communities

Most of us can remember struggling to understand who we were when we were children, and where we were in the world. To people whose work keeps them close to children—educators, doctors, religious leaders, and neighborhood organizers—it's clear that kids are constantly searching for ways to understand themselves and their fast-changing communities. It's clear, too, that kids very often express what they see more directly and more compellingly than adults. So it's helpful that we try to learn—relearn, really—how children see and understand the changes going on in their worlds.

LTP helps children put what they see into a form that communicates their concerns to people who know nothing about them, their situation, or their community. By giving children the tools to tell their stories to their own communities as well as the outside world, we're encouraging community groups to take risks by focusing on documenting the challenges and tensions of their lives.

Building a Program

To begin with, seek out organizations that are doing interesting work in communities where you'd like to work. In India I located the Self-Employed Women's Association (SEWA), a grassroots union that organizes around women's economic and political rights. In Mexico I was associated with Sna Jtz'Ibajom (*Snah´-tzee-bah-home´*), a Mayan writers' collaborative running a literacy program in the native language, Tzotzil. In Kentucky I worked with Appalshop, a media collective that preserves and celebrates Appalachian culture.

Basing a project in a community organization gives me a strong connection to local people, and what I learn about them helps shape each project. Since I begin with the expectation and hope that a project can and will continue without me, I search for an organization whose mission meshes with mine and who also has the capacity to carry on the work after I leave. I also work closely with someone from the community and train that person in LTP methods. Sometimes I collaborate with local photographers, as I did with Victor Matom in South Africa or Barry Norris and Antonio Turok in Mexico, but more often I work with people who have little or no experience in photography. The most important thing is that the person knows

children well and is open and relaxed enough to let them work the way they want.

Enlisting the help of local people or a community organization in selecting a group of kids to work with is very helpful. As I can't work with all the children who might like to learn photography, I usually lean toward offering the opportunity to those who wouldn't otherwise have access to self-expression and technology. I recognize that the choice of students will influence the way the project evolves.

In India I could have set up the project in a school, but this would have excluded half the children who wanted to participate—lower-caste children who, precisely because of their caste or family responsibilities, did not attend school. With this in mind, we chose to work in a villager's front yard, instead of a school, and recruited a group divided evenly between those who went to school and those who didn't (there was also a fifty-fifty split of boys and girls). This decision to include children from lower castes meant that I was cutting out the Brahmin, or higher-caste, children who do not associate with lower-caste children. Later on in the project, once the children's pictures began to circulate in the village, there came a moment when the village leader, a Brahmin, asked if his son could participate. Naturally I agreed.

At the outset of each project I try to spend several weeks getting to know the local people, just hanging out, listening and learning as much as possible. It's crucial to get a feeling for what the kids are like, what they would most like to do, and what projects would be easiest for them to conceive of and carry out.

The first thing I usually ask children to take pictures of (in a community as opposed to a school-based setting) is their families. The concepts underlying the shooting of self-portraits are complicated, especially if you've never taken any pictures or owned any images or held a camera. Kids need time to get used to taking pictures before they can understand the many ways to use a camera.

At first, the children I worked with in Morocco wanted only to photograph monuments and historical sites. To them taking pictures was about documenting traditions and venerable places. This desire seemed oddly unchildlike, so I urged them to be freer, to photograph people and situations that were part of their lives as children. Later, when the children came back with the pictures they'd taken out in their neighborhoods, many of the

images were blurry and out of focus. This was surprising, since by then they had mastered the mechanics of the cameras.

Adult friends among the Moroccans assured me that it would not be a problem for the kids to take pictures in their communities. But the children told stories that indicated quite the opposite. They spoke of hostile encounters with people who did not want to be photographed, who scolded them and threw rocks. (The kids took the community's resistance as a challenge rather than an impediment.)

This sort of reaction brings home the force of people's feelings about photography, and the unarguable reality of opposing points of view—between children and adults, insiders and outsiders. I've continually had to adjust my outsider perspective and figure out ways to understand and work within the confines of my new surroundings, to adapt to the rules of the community and its culture.

It helps to remember that virtually every stage of the project is a shared enterprise. In all the communities where I've worked, the children and I have organized an exhibition. In Colombia we displayed the children's photographs at a library in the middle of the market square so the campesinos could view them on market day. In India we invited everyone in the village, whether or not they'd ever set foot in school, to the village school. The pictures were hung from a clothesline in a bare room. In South Africa the photographs were shown at Johannesburg's Market Theatre, the first integrated theater in the country. We also made a set of laminated prints for use in each of the three South African neighborhoods we worked in.

I donate the darkroom equipment and cameras to local organizations, and try to help them find ways to sustain the project. If any of the children's photographs are sold, I send money to the communities where the pictures were made to help them buy more film and chemicals.

I never expect the project to be the same once I leave, and I find it fascinating and instructive to see the ways in which communities make the process their own. In Mexico, the Mayan writers' collective I worked with has expanded; they've built a fully equipped darkroom. I was able to send them enough money from the sale of children's prints so that now all the students I worked with own 35mm cameras. In India the women's union continues to use photography, but more as an organizing tool than as a method of encouraging children's self-expression.

South Africa

ROSE RADEBE

Communities in Transition

Pictures can be helpful in grasping the daily miracle of how people caught in social upheavals carry on with their lives. It is vanishingly rare for us to experience such lives from their own perspective; the mass media tend to carry only the most theatrically predictable versions of them. Stories deemed worthy of attention are filtered through the eyes of professional journalists with very little connection to the worlds they cover. Yet children remain acutely attuned to the subtleties and hard realities of what is happening around them, and their perceptions come through strongly in their photographs.

Most of my work has been done in communities going through rapid change or outright crisis. Typically, the crises arise from conflicts between groups with a long history of antagonism, or from the abrasive coming together of groups with different cultural backgrounds.

In an earlier chapter I wrote about working in Black River, a Canadian reservation whose troubles would be beggared by the word "crisis." The geography of the area is such that the reservation is split in half by a river; the whites were on one side and the Eskimos and Indians, with whom I was working, were on the other. The whites held political sway over the Indians, and it was the culture and language of the whites that was being taught to Indian children. An Indian from Ottawa was trying to organize the local Indians, and his advocacy of social and economic justice was creating divisions between the native people and the Catholic Church, the real power on the reservation.

Coming into this environment as an observer, I saw photography as a way for the reservations' children to define their experience and discover that they could achieve something others could not. Time after time, the children's imagery cut through the haze of misconception that characterized

If the African National Congress comes to power, things will change. Where I go to school, white people live in the biggest houses. You find six houses in a yard and they have a swimming pool, three tennis courts. The whites will still have the big houses, but we'll also have big houses. It's going to be fair.

At school I feel comfortable with white people, but sometimes their mothers, they just scream, especially at the black kids, for nothing.

If I have a party I can only invite the African kids. The white kids say they're scared. That makes me feel uncomfortable because we're not scared of their place. Once my best friend said to me, "I'll only come to your house, if you promise you'll put me in your pocket." I said, "You can ride the limousine here because I'm definitely not putting you in my pocket."

I think white people are afraid of black people. You know, when a black person goes up to a white person and says fast, "Hey! Where is this place?" then the white person is scared, but if he goes up to a white person and says very politely, "Missus, can you please tell me where is this place?" they say, "Ah, she's a fool so what does it matter if I tell her the wrong place. Who cares?"

ZENI MBOBO, SOWETO, SOUTH AFRICA

Neighbors in the yard,
South Africa
ANTHONY KINNEAR

the outsiders' views of Indian life. It was in Canada that I became committed to the idea that children have a special ability to capture and convey what it feels like to live in their worlds.

SOUTH AFRICA:
BRINGING
PEOPLE TOGETHER

When I went to South Africa, Nelson Mandela had just been released from prison. The apartheid government was still in control, but the country was bracing itself for enormous change with the transfer of power from the Conservative Party to the African National Congress (ANC). I set to work with three different groups of children—one from a black township, another from a rural black settlement, and a third from a white Afrikaner suburb. The children's photographs and writings, of course, expressed very different worldviews.

An Afrikaner child, Anthony Kinnear, photographed the front yard of a house in Glenesk, a white working-class neighborhood of Johannesburg. The picture does an appallingly accurate job of rendering what it felt like to be in that worried neighborhood at that worried time.

The picture is essentially a portrait of two women in their twenties—though the stress in their expressions makes them look years older. At first glance the composition shows a perfect suburban world: a woman and her baby, a neighbor, a dog. Yet as you look more closely, the image becomes quite ominous. You notice, for one thing, that the neighboring houses are cut off from each other by the razor wire looming menacingly in the foreground. The photographer was a child familiar to the people in the picture, so we can assume that the fear that rules the picture is not the result of any fear of the photographer on the part of the subjects.

Things have changed—like before there wasn't a lot of blacks. They couldn't move next to your house. Now everywhere there's blacks moving in the schools and they stay next to you because it's the New South Africa. I don't like it actually, because the blacks, they take over. Saturday when we were at the Pic 'N Pay, they bumped us out of the way to go and put their stuff down on the counter. My gran wanted to hit them. They frighten us. Then they say "Sorry, Missus, sorry, Missus, sorry, Missus." Some of the blacks, they act well. They go and work and don't steal other people's stuff. Two of them stole my bicycle, my Mongoose. They are killing a lot of white people now. They say it doesn't matter. Every day they'll kill a thousand or a hundred. It makes me feel bad because then there's not going to be a lot of white people around. Soon there will be just a few white people here in Glenesk. My gran asked for another lady if there was going to be a place for her, if someone moved out. The housing people said no. There's about a thousand white people on the waiting list and the rest is four thousand blacks. I think Mandela is going to take over. I don't like him because he doesn't tell the black people what to do. He must tell them because he's the chief of them. He must tell them not to go and steal other people's stuff. They must go and work for their money.

JOHN JACKSON, JOHANNESBURG, SOUTH AFRICA

The image conveys, with confessional trust and intimacy, the relentless anxiety and siege mentality of the neighborhood, the terror of the whites at the prospect of being overrun by the blacks, and their longing to shut themselves away from the world surrounding them.

Rose Radebe, a young black girl from Soweto, took a photograph of a conversation between two men that captures the flavor of what is usually thought of as a notoriously violent community. The white refrigerator in the background highlights the storyteller, whose hands are eloquently in motion. The composition is truly striking in the graceful way it brings together intimacy, liveliness, and expressiveness, and it is all the more striking because of the way these relaxed elements play against the media stereotype of a violent Soweto.

The reception of the photographs in South Africa amounted to a media frenzy. The reason, I suspect, was that the pictures so nakedly and pathetically revealed the isolation of the Afrikaner community. It was something that needed to be said.

CHIAPAS, MEXICO: SEEING CULTURE RESPECTFULLY

In the fall of 1991, the year before the Zapatista uprising in southern Mexico, I spent several months in Chiapas. I had been commissioned by Polaroid to do a project celebrating the five-hundredth anniversary of Columbus's voyage. I chose to work in both Indian and non-Indian communities. The Mayan writers' cooperative in Chiapas asked me to incorporate photographs into a literacy program in Tzotzil, the native language of the Mayans. Tzotzil had only recently become a written language, and was being taught for the first time to Indian children. While there, I also worked with a group of Ladino kids, descendants of the first Spanish settlers.

The children in the Mayan communities had very well-formed ideas about photographs, and their use of photography was very controlled. Among the adult Indian community, there was a long-standing conviction that foreigners were trafficking in their images and that photographs denigrated their religion. One result of this near-taboo vis-à-vis photography was that the Indian children were not free to photograph whatever or wherever they wanted. The town center, being a sacred place, was off-limits. Still, everyday the Mayan children could see busloads of tourists taking pictures in the sanctioned places, buying souvenirs, and clambering back on their buses to get to the next picturesque destination.

There was a lot of suspicion in the Mayan community about local kids taking pictures at all. Pictures were pictures—what difference did it make if they were taken by their own children? Once the kids started taking pictures, however, the mood shifted. Some people in the community became less concerned about how they were perceived from the outside. "We used to be afraid," said the father of one of my students. "We were afraid of photographs because we never took them. And now we are not afraid."

I was acutely aware of the tensions between the Indian and the Ladino people in Chiapas. But there was no overt conflict, not then. (The antagonism erupted a year later with a revolt that drew the world's attention.) Polaroid, the sponsor of my project, had initially intended to open an exhibition of the children's photographs in Mexico, then to move the show to museums in Latin America and the United States. Some Polaroid executives in Mexico loved the pictures and hung them in their offices, but ultimately the corporation proved to be more cautious than the Mayan elders; Polaroid ultimately declined to show the work in Mexico. Their reason— they cited a picture of an Indian girl carrying water for her family—was that they did not want Polaroid to be perceived as supporting a "backward image" of Mexico. They were more comfortable with a photograph showing a Ladino girl engaged in what Americans think of as a typical childlike activity—playing with her Barbie dolls.

It is one of the hazards of doing this kind of work that one cannot sidestep photography's potential for controversy. And the children's impulse toward truth-telling does not always satisfy adult expectations of apolitical innocence.

Some time after my stays in Chiapas and South Africa, we made an effort to get American magazines to print the children's photographs. Both countries were getting the kind of media attention reserved for major geopolitical disturbances. But no publication, not even the more liberal forums, would print the children's photographs, though some entertained the idea for a while. I came to believe that even though the pictures were timely and informative—in a word, newsworthy—they were too complicated. The children's imagery did not conform to the packaged, black-and-white preconceptions thought to be an essential part of intelligible mass-media conversation.

Portrait of my dad
and Jerry
RASHAD MILLIGAN

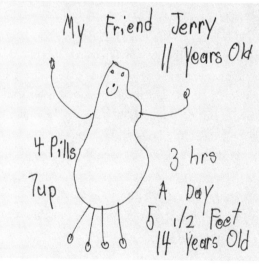

My friend Jerry
RASHAD MILLIGAN

John Moses is a photographer and a pediatrician. Along with another photographer associated with the Center for Documentary Studies, Julie Stovall, John and I came to feel that gravely ill children and their families might benefit from taking a less passive stance toward their disease, even when faced with such an overpowering reality as terminal illness. With writing and photography we looked for ways to engage children who were seriously ill or who had a close family member who was seriously ill.

Drawing on our connections to Duke University, we created a university seminar that pairs college students with children at Duke Hospital. The course uses literature, photography, and children's drawings in a hands-on documentary approach to gain an understanding of illness through the eyes of children. Each college student works with and mentors a child who is taught to use the camera as a way of exploring illness as it affects his own and his family's lives.

In many ways this project upends conventional protocol, at least to the extent that it encourages sick children to express what they know about their condition. What struck all of us who worked with these children is that their illness is not the most important fact of their lives. They remain children, and continue to see the world through children's eyes, especially in their use of fantasy to imagine a different life. For instance, Rashad Milligan, who was losing his vision to a degenerative eye disease, wrote about himself and an imaginary friend, Jerry, who was all the things that he, Rashad, was not. In his photographs, Rashad left an empty space for his friend.

This university-hospital-based project was also important for the families of the children, giving them an opportunity to deal with the illness creatively, as a family, with someone other than a health-care worker. They had a powerful new way to communicate and cope. Parents Michelle and Rick Brandhoefer from North Carolina, wrote about the experience:

> I first met Jerry when Rashad was describing this picture. Rashad said it was a photo of his dad and Jerry, his invisible friend. "Jerry is fourteen, tall, thin, and wears contact lenses. He always wears red and blue shoes, green pants, a yellow shirt and a Space Jam jacket." He and Rashad watch TV, like the same programs, eat the same food—pizza. Jerry helps Rashad see better and he helps keep him from falling. He stands up for Rashad when other kids are picking on him. Rashad can squeeze his eyes closed, and when he opens them, he can see Jerry. At night, Jerry sleeps inside Rashad's head.
>
> MARSHA SEATON, Volunteer, North Carolina

When our son David was diagnosed with a brainstem glioma, our family went through many changes. One of our concerns was that our daughter Stacie would not talk openly about David's illness with us. We wondered how she was dealing with the drastic physical changes; her brother, who was once so vibrant and active, was now quiet. She had lost her #1 playmate.

We got her involved in this program. She was able to express her feelings through pictures, and at times it brought David and Stacie together, where they had been torn so far apart because of this progressive disease. At the end of the program Stacie and Julie, the student volunteer who worked with her, put the pictures together with descriptive labels. They prepared an exhibit, and a journal was written by the student about our family. The journal is an enduring reminder of the family's experience, told sometimes in Stacie's own words, sometimes using quotations from us.

Every family develops a different way of coping. Things that we are so much aware of go unnoticed; they're taken for granted. These children bring the real value of what is really important in this life through their eyes. No two children's thoughts are the same. Being adults, we're supposed to teach our children, but what I've learned, the children already know. We adults have forgotten, and these children are teaching us.

When I asked Stacie what the most important part of this class was for her, she said, the memories. She was able to capture the moment on film and turn this into a creative work. As she grows she will always remember feelings she had because they're captured on film.

HOUSING: CHILDREN AND THEIR SENSE OF NEIGHBORHOOD

In 1993 I was asked to help produce a document that would measure the effectiveness of a housing renovation program that had been funded by a coalition of organizations in Chattanooga, Tennessee. The Lyndhurst Foundation sponsored the study in hopes of learning from neighborhood children how they and their families felt about their changing communities.

For two summers I worked with a young photographer, Jeff Whetstone, and a graphic artist, Marta Urquilla. Jeff and Marta, in turn, held photography and writing workshops with children from three of Chattanooga's low-income housing communities. One community was being renovated;

another was a housing project slated for renovation; the third was a newly built housing cluster heralded as a "model community."

When the project was completed and the photographs spread out before us, we were startled to see the differences between the sets of photographs. The "model community," Orchard Village, came across as empty and desolate. While many of the adults took pride in living in new housing, the children had quite another take on the neighborhood. They felt cut off from the easy mix and flow of street life, from the kind of interaction that adults had come to regard as threatening rather than neighborly.

The older community of cinder-block houses, which appeared decrepit to outsiders, came across in the children's photographs as vibrant, lively, and close-knit. The children who made these pictures, like most kids I've worked with, were able to see values that others, even the adults in their own communities, did not anticipate and certainly didn't see.

> Listen to this rap from start to finish,
> I'm talking about this neighborhood called Orchard Village.
> The houses are pretty and they will do,
> We have colors from yellow to gray to blue.
> You can hear things drop, even a feather.
> That's one problem,
> These houses are too close together.
> When it gets real boring, kids look real dumb,
> That's why we need a place to go to have fun.
> The grown-ups in the hood tell us what to do.
> They say that we have a bad little crew.
> One lady, she thinks she run this hood,
> But that's not going to do her no good.
> She watches us after dark,
> She even tries to tell our parents where to park.
> Her husband is cool, I knew him from the past.
> He gave my friend a job cutting grass.
> Kids on the corner, needing help,
> That's why we need a place to play,
> And that is all that we have to say.
> Peace, peace, peace, peace.
> —TERRY JENKINS AND JERMAINE WASHINGTON, TENNESSEE

Not so long ago Durham, North Carolina, was primarily a Baptist community. Over the past decade or so, in a pattern typical of many other American cities, immigration has changed its demographics so that Durham has become home to most of the world's major religions. Predictably perhaps, tensions have developed between these new groups and the established religious community.

Ray Williams, the education curator of the Ackland Museum in nearby Chapel Hill, North Carolina, invited me to work with children in an exploration of their religious beliefs. The museum has an extensive collection of religious objects from Hindu, Jewish, Buddhist, Christian, and Islamic traditions, and Ray was interested in developing a project that might stimulate children to reflect on the practice of their faith in contemporary situations. The project also seemed a way also to foster interfaith understanding by drawing on different forms of religious representation in response to the changing demographics of the area.

We worked with children from each of five faiths represented in the museum's collection and began by discussing what they could and could not photograph of religious life. We went on to talk about the difference between public ceremonies and private religious practices, and about the artifacts used in each. We asked the students to photograph examples of religion in their homes, then photograph public ceremonies (if possible), and finally create photographs to illustrate the central stories of their faith.

Other Programs

A lot has changed since I began this work in 1969. The global economy has brought us closer together. Most people are now willing to concede that there are many different points of view, that each culture has its own way of seeing. Perhaps as part of this expanding notion of the world, we are also more likely to give children a voice in describing their own worlds.

Photography programs for children have proliferated in every part of the globe. To mention just a few: Caroline Wang, a photographer and public health worker, developed a program called Photovoice. Initially she gave cameras to rural Chinese women and asked them to document their lives. The photographs were used to stimulate conversation about social services that might improve the women's communities, and the Ford Foundation used the women's recommendations to formulate grant-making guidelines in rural China. The program now includes sites in the United States as well as other areas of China.

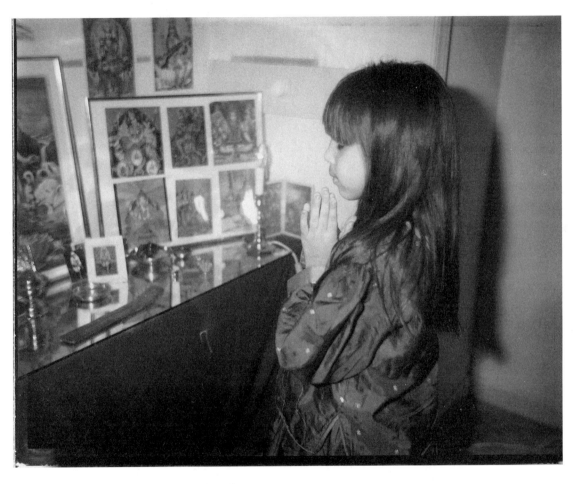

My sister kneeling for prayer
RAINA BATRA

I saw Mami dead
YAMROT ALEMU

Dear Mami,

Once upon a time in the hospital, you rose from your bed and came to the pediatrics ward, bothering the hospital employees, and that was all to see us. You were crying, sitting on a stair, saying, "Bring my children to me; otherwise I will kill myself!"

We also used to visit you in your bed. You gave us bananas. During all this, my younger sister and I used to cry bitterly. We were living this way before you separated from us on September 13, 1992.

We didn't share our love enough; you passed away. With this, I quit my memory.

Your daughter,

Yamrot Alemu

Eric Gottesman, a volunteer with UNICEF, used photography and writing to work with Ethiopian children whose parents had died of AIDS. Among other things, the children photographed their dreams and wrote letters to their absent parents. This work gives us a way to see beyond the statistics and news stories, to look at the AIDS crisis in Africa from the perspective of those living with it every day.

Dwayne Dixon, LTP's project coordinator in Durham, took cameras to a relocation camp in Thailand where he worked with young refugees from Burma. These displaced children were able to use the cameras to encourage a sense of community and forge links to their past.

In the summer of 2000 I developed an LTP project with Karen children in the Mae Kong Kha Refugee Camp on the Thai border with Burma. Fleeing attacks from Burmese soldiers, the Karen people, an ethnic minority in Burma, sought safety in this camp, which rapidly grew from 3,000 to 14,000 people. It was a precarious and dangerous situation.

Our classroom was a large bamboo hut; the translators were young women studying English. We talked about what it meant to be represented in photographs, about who created those representations, and whether photographs can speak across languages. I asked the children about the meaning of community and how they experienced it in the camp as opposed to in their villages. They wrote about community and practiced using cameras.

The students began to see that they could use pictures to tell stories about their past experiences by creating evocative visual symbols. When I asked them how they had arrived at the camp, their responses began with stories of flight. I wanted them to think about ways they could tell about their journeys with words and drawings and then to think of ways they could make photographs of these events. They asked such questions as: "How can I make photographs of my own story when I am taking the pictures?" "Is it OK if the jungle here doesn't look like it did back home?" "What if members of my family aren't alive anymore?" Together we devised solutions, and then I introduced the subject of dreams. Having tackled the notion of dramatizing an actual past event, the students felt comfortable relating dreams and making them "real" in photographs.

The kids went out and photographed throughout the camp. The

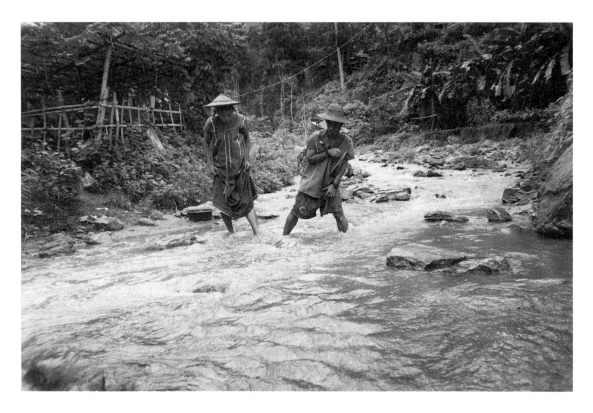

The Burmese soldiers came. When we ran, we had to cross the river.

SAW THA KYAW

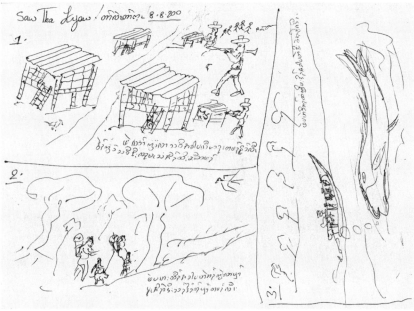

oldest boy took a picture of an iron forge. A girl who was shy and quiet wrote the most interesting story about killing, cooking, and eating a goat. She grasped the whole sense of narrative—it was very symbolic. Other children portrayed their dreams of being attacked, of terror and flight.

A community developed around this project, and the three translators became the primary teachers. By working together, kids from different sections of the camp began to make connections, building new relationships. Taking pictures of each other and of their families was also important for everyone because so many families had lost loved ones. Many people became involved: teachers, camp leaders, the students and their families. We put up a photo exhibition, and this helped bring still more people together from different parts of the camp, strengthening the community as it struggled to adapt to the harsh conditions of camp life.

—DWAYNE DIXON, LITERACY THROUGH PHOTOGRAPHY PROJECT COORDINATOR, NORTH CAROLINA

As we've seen, the process of making images and writing about pictures is powerful and revealing in a variety of contexts and settings. Providing children with an opportunity to master photography is to allow them access to expression. If their work creates greater understanding between people and increases the possibility of intergenerational dialogue, then Literacy through Photography serves an important purpose. In order for this to take place, however, working with children must be done responsibly. However tempting it may be, it is not enough to put cameras in the hands of children and extol the virtues of their photographs as the revelations of innocent eyes. Children, like all of us, must be given the necessary tools, technical and conceptual, to work with, but it can be counterproductive to claim that access to free expression in photography and writing alone will necessarily make for positive change in a child's life. LTP is one method that teachers, parents, and children can use to create an environment in which they can appreciate and honor the pleasure and beauty of self-expression, as well as come to a greater understanding of how others see the world.

Many people I've worked with or who have attended our workshops have adapted LTP to suit their needs. I can readily imagine interfaith groups, church youth groups, day camps, community centers and community

service projects, educational outreach programs for children of seasonal farm workers, adult literacy and GED programs, teen pregnancy programs, intergenerational groups, retirement communities and senior centers, and many other kinds of organizations taking advantage of Literacy through Photography.

This is a time when artists and writers are reaching out to work in far-ranging communities, and when arts institutions are trying to reach a wider public through education programs. We hope this book will act as a guide in setting up respectful collaborations between teachers and students, parents and children, community workers and their constituents, artists and schools, and schools and arts organizations.

Resources and Readings

Programs Literacy through Photography Workshops
Center for Documentary Studies at Duke University
1317 West Pettigrew Street
Durham, North Carolina 27705
www.cds.aas.duke.edu/ltp/index.html
919.660.3655

Literacy through Photography (LTP) offers week-long summer workshops, taught by LTP staff members in conjunction with the Durham Public School's Staff Development Center. Teachers, artists, photographers, and educators from around the world attend these workshops. For teachers the workshops provide hands-on experience in taking, developing and printing photographs, and writing about them. The training emphasizes insight into the creative process as well as a technical understanding of photography. Applications for registration are available on the LTP Web site.

LTP is a nationally recognized model for K–8 arts education, LTP's curriculum has expanded to include both basic and advanced-methods workshops as well as a series of thematic workshops on special topics. LTP also offers consultation and on-site visits for schools and organizations interested in setting up their own programs.

Artists in the Classroom: Ten Collaborative Projects, edited by LTP staff members, Dwayne Dixon and Lori Ungemah, is a handbook describing ten projects by artists working with young students and their teachers in LTP classrooms. It provides ideas and examples for teachers to try in their own schools, and is available for purchase on the LTP Web site.

Literacy through Photography is based at the Center for Documentary Studies. CDS is an interdisciplinary educational organization affiliated with Duke University, and is dedicated to advancing documentary work that combines experience and creativity with education and community life. CDS offers academic, community, and continuing education courses; sponsors research and fieldwork; presents exhibitions and public programs; and publishes books. For a free copy of the CDS quarterly newsletter, *Document,* send an email to docstudies@duke.edu or write to the street address above.

Ansel Adams Center
Friends of Photography Education
Programs
250 Fourth Street
San Francisco, CA 94103
415.495.7000
www.friendsofphotography.org/educa-
tion.html
edu@friendsofphotography.org
A variety of photography-related
education programs

Appalshop
Madison Street
Whitesburg, KY 41858
606.633.0108
www.appalshop.org
info@appalshop.org
An arts and education center which cele-
brates the culture and voices the concerns
of people living in the Appalachian
Mountains

Center for Creative Photography
The University of Arizona
Tucson, AZ 85721-0103
520.621.7968
www.creativephotography.org
oncenter@ccp.arizona.edu
CCP offers ideas and educators' guides
for using photography
with children.

FOTOFEST, Inc.
1113 Vine Street, Suite 101
Houston, TX 77002
713.223.5522
www.fotofest.org
ltp@fotofest.org
FOTOFEST sponsors a program
that uses photography as a basis for
learning in the Houston schools.

Getty Center for Education in the Arts
401 Wilshire Boulevard, Suite 950
Santa Monica, CA 90401-1455
www.getty.edu
www.artsednet.getty.edu
The Getty offers lesson plans and
a variety of resources for teachers inter-
ested in art education.

Museum of Photographic Arts
The Visual Classroom: Integrating
Photography into the School
Classroom
www.mopa.org
The Visual Classroom is an excellent
resource guide for teachers in grades
4–12

NECA
202.238.2379
www.teachingforchange.org
A great source of multicultural educa-
tion resources and ideas

Polaroid

www.polaroid.com/work/teachers/index.html

Polaroid's education program provides teachers with resources for visual learning.

Photovoice

www.photovoice.com

This Web site describes the Photovoice method and its projects to promote social change through photography.

Society for Photographic Education

P.O. Box 2811
Daytona Beach, FL 32120-2811
904.255.8131 ext. 3944
www.spenational.org
SocPhotoEd@aol.com

A national resource center for photographic education

Youth in Focus

3722 S. Hudson
Seattle, WA 98118
206.723.1479
www.youthinfocus.org

A program that teaches photography to at-risk teens, winner of the 2000 Presidential Coming Up Taller Award.

Museums

Most museums and local arts councils have excellent educational programs and many are eager to collaborate with teachers. Check your local museums and arts societies for information and resources as well as for field-trip opportunities for your students.

Funding Sources

- Local school systems for teacher initiative grants or discretionary funds
- Parent-teacher associations and organizations
- State and county arts councils
- Local foundations and corporations
- Local colleges and universities (art and education departments)
- In-kind donations: photography stores, Wal-Mart, Kmart, Home Depot
- The Foundation Center (best source for information about national foundations) www.fdncenter.org

Readings

Photography and Art by Children and Others

Berger, Maurice. *Hands & Minds: The Art and Writing of Young People in Twentieth-Century America.* New York: Alliance for Young Artist and Writers, Inc., 1998.
Catalog of an exhibition Berger curated celebrating seventy-five years of scholastic art and writing awards. Includes children's photographs and writings from the Black Self/White Self project.

Cahan, Susan and Zoya Kocur. *Contemporary Art and Multicultural Education.* New York: Routledge/ New Museum of Contemporary Art, 1996.
Artists outline projects that connect everyday experience, social critique, and creative expression with classroom learning.

Cech, John. *Jacques-Henri Lartigue: Boy with a Camera.* New York: Four Winds Press, 1994.
Lartigue, a young French boy in the early 1900s, took playful and perceptive photographs of his family and surroundings. One of the few published examples of a child's photographs.

Coles, Robert. Margaret Sartor, ed. *Their Eyes Meeting the World: The Drawings and Paintings of Children.* New York: Houghton-Mifflin, 1992.
Coles looks at children's drawings and discusses what they might mean.

Franklin, Kristine L. and Nancy McGinn. *Out of the Dump: Writings and Photographs by Children from Guatemala.* New York: Lothrop, Lee and Shepard Books, 1995.
A photojournalist living in Guatemala, McGinn started a photography project with children who survive by picking through garbage.

Mathare Youth Sports Association. *Shootback: Photos by Kids from the Nairobi Slums.* London: Booth-Clibborn Editions, 1999.
A compilation of writing and photographs by children living in the poorest section of Nairobi, Kenya

Women of Yunnan Province. *Visual Voices: 100 Photographs of Village China by the Women of Yunnan Province.* Yunnan, China: Yunnan People's Publishing House, 1995.
Photographs by rural women in China documenting their daily lives. Useful as an example of how photography can contribute to social change.

Theories about Young People and Art

Fineberg, Johnathan, ed. *Discovering Child Art: Essays on Childhood, Primitivism, and Modernism.* Princeton: Princeton University Press, 1998.
This book brings together thirteen distinguished critics and scholars to explore children's art and its profound influence on the evolution of modern art.

Fineberg, Johnathan. *The Innocent Eye: Children's Art and the Modern Artist.* Princeton: Princeton University Press, 1997.
Fineberg shows how many of the greatest masters of modern art were directly influenced by children's art.

Worth, Sol and John Adair. *Through Navajo Eyes: An Exploration in Film Communication and Anthropology.* Bloomington: Indiana University Press, 1972, 1997.
An account of Native Americans' learning to use film technology to make their own films in their own idiom.

Technical Help and Photography Criticism

Barrett, Terry. *Criticizing Photographs: An Introduction to Understanding Images.* Mountain View, Ca.: Mayfield Publishing Company, 1990, 1996, 2000.
Offers a clear process for looking at and analyzing photographs; includes models of criticism that teachers can adapt for classroom use and discusses different ways to write and talk about photography.

London, Barbara and John Upton. *Photography*, 6th ed. Reading, Mass.: Addison-Wesley, 1997.
General overview of black-and-white photography and color photographic techniques. Well written with many illustrations.

Horenstein, Henry. *Black and White Photography: A Basic Manual,* 2nd revised edition, 1983, and *Beyond Basic Photography: A Technical Manual,* 1977, Boston: Little, Brown.
A well-written, easy-to-understand series; the first title for beginners, the other for more advanced practitioners of black-and-white photography.

Shore, Stephen. *The Nature of Photographs.* Baltimore: Johns Hopkins University Press, 1998.
An understandable introduction to photographic seeing by longtime educator Stephen Shore

Szarkowski, John. *The Photographer's Eye.* New York: Museum of Modern Art, Doubleday, 1966.
Seminal work on the nature of photography by a former curator of the Museum of Modern Art

Szarkowski, John. *Looking at Photographs: 100 Pictures from the Collection of the Museum of Modern Art.* New York: The Museum of Modern Art, 1973.
Short essays by one of the best writers about photography on one hundred photographs in the museum's collection.

Willis, Deborah, ed. *Picturing Us: African American Identity in Photography.* New York: The New Press, 1994.
Personal essays by African American writers, filmmakers, and critics who explore how African Americans have been depicted in photographs and how these images are read. It is an important and accessible book about race, representation, and photography.

Photography Books

Davidson, Bruce. *East 100th Street.* Cambridge: Harvard University Press, 1970.
These photographs are useful in getting students to think about community.

DeCarava, Roy and Langston Hughes. *The Sweet Flypaper of Life.* Washington, D.C.: Howard University Press, 1984.
A compelling example of how to blend photography with narrative writing

Disfarmer, Mike. *Disfarmer (1939–1946): Heber Springs Portraits.* Santa Fe, N.M.: Twin Palms Publishers, 1996.
Extraordinary portraits by a studio photographer which are useful for discussing poses, facial expressions, camera angles, and props

Erwitt, Elliot. (1988) *Personal Exposures.* New York: W. W. Norton.
A fine series of images that demonstrate how to tell stories with photographs

Hambourg, Maria Morris, Francoise Heilbrun, and Philippe Neagu. *Nadar.* New York: Metropolitan Museum of Art, 1995.
Nadar's portraits of French people in the mid-nineteenth century give a glimpse into photography's historical value and also show young people the great range of possibilities in making portraits.

Hill, Iris Tillman, ed. *Beyond the Barricades: Popular Resistance in South Africa.* New York and Durham, N.C.: Aperture Foundation, Inc., and the Center for Documentary Studies at Duke University, 1989.
A useful book for discussing community and race issues

Keita, Seydou. *Seydou Keita.* Zurich—Berlin—New York: Scalo, 1997.
Portraits taken by a studio photographer from Mali, West Africa, that never fail to intrigue students

Levitt, Helen. *A Way of Seeing.* Durham: Duke University Press in association with the Center for Documentary Studies at Duke University, 1989.
Fabulous photographs of Harlem in the '30s and '40s to show kids, especially when talking about community

Minahan, John. *Arthur Tress: The Dream Collector.* New York: Avon Books, 1967.
Photographs made to illustrate and explore children's dreams

Namuth, Hans. *Los Todos Santeros: A Family Album of Mam Indians in the Village of Todos Santos Cuchumatan, Guatemala, C.A., 1947–1987.* London: Dirk Nishen Publishing, 1989.
Portraits of community members with objects of their own choosing

Rogovin, Milton. *The Forgotten Ones.* Buffalo: The Buffalo Fine Arts Academy, 1985.
Rogovin's portraits provoke discussion about what photographs can reveal about personality.

Sander, August. *Men without Masks: Faces of Germany, 1910–1938.* Greenwich, Conn.: New York Graphic Society Ltd., 1973.
Severe yet intimate portraiture, which can stimulate discussion

Tannenbaum, Barbara, ed. *Ralph Eugene Meatyard: An American Visionary.* Ohio: Akron Art Museum; New York: Rizzoli, 1991.
Provocative images to show when exploring dreams

Willis, Deborah, ed. *Van Der Zee Photographer: 1886–1983.* New York: Harry N. Abrams, 1993.
Wonderful studio portraits taken in Harlem

Willis, Deborah, ed. *Reflections in Black: A History of Black Photographers, 1840 to the Present.* New York: W. W. Norton, 2000.
A comprehensive history whose pictures tell many different stories about African American life

Teaching Writing

Atwell, Nancie. *In the Middle: New Understandings about Writing, Reading, and Learning,* 2nd ed. Portsmouth, N.H.: Boynton/Cook, 1998.
Geared toward middle-school students

Calkins, Lucy. *The Art of Teaching Writing.* Portsmouth, N.H.: Heinemann Educational Books, Inc., 1986.
Very useful as a way to understand how children develop as writers and what teachers can do to help them in the process

Koch, Kenneth. (1970) *Wishes, Lies, and Dreams: Teaching Kids to Write Poetry.* New York: Vintage Books, 1970.
An account of Koch's teaching writing to kids in the New York City Public Schools. Includes wonderful examples of kids' poetry.

Autobiographical Writing

Cisneros, Sandra. *The House on Mango Street.* New York: Vintage Books, 1994.
The author writes beautifully from a child's perspective.

Wideman, John Edgar. *Sent for You Yesterday.* Boston: Houghton-Mifflin, 1997.
Wideman's use of dialogue is illuminating in talking about the ways we use language in different contexts. Especially helpful in developing an African American alphabet project with middle-school kids.

Books about Teaching

Ashton-Warner, Sylvia. *Teacher.* New York: Simon and Schuster, 1963, 1986.
An account by a teacher working with Maori students in New Zealand. She tried to teach reading by a process that emotionally connected her students to words.

Delpit, Lisa. *Other People's Children: Cultural Conflict in the Classroom.* New York: The New Press, 1995.
A collection of essays that explores the racial and cultural blind spots of progressive education, the power imbalances of our society as reflected in our nations' classrooms, and the gap in cultural understanding between white teachers and students of color.

Foster, Michele. *Black Teachers on Teaching.* New York: The New Press, 1997.
A study of African American teachers, now and in the past. It includes their voices and perspectives, an important source of information, the author argues, about how to improve the education of African American children.

Paley, Vivian. *Kwanzaa and Me: A Teacher's Story.* Cambridge: Harvard University Press, 1995.
Paley, a veteran white teacher, scrutinizes her own racial identity and her interactions with students, particularly those of color.

Videotapes and Films

Ewald, Wendy. *South Africa.* Filmed by Tom McDonough, 1992.
Twenty-minute video about Wendy's work in South Africa.
Contact: tmcdono865@aol.com

Ewald, Wendy. *Mexico.* Filmed by Tom McDonough, 1991.
Twenty-minute video about Wendy's work in Chiapas, Mexico.
Contact: tmcdono865@aol.com

Ewald, Wendy. *Portraits and Dreams.* Produced by Appalshop.
Twenty-minute slide video on Wendy's work in Kentucky.
Available from Appalshop: 606.633.0108

Woolcock, Penny, director. *Vile Bodies: Kids.* Produced by Blast Films.
One-hour video that explores the way four photographers, including Wendy Ewald, portray children.
Contact: Blast Films, 225a Brecknock Road, London N19 5AA, England

story
and
pictures
by
greg
cornett

printed

in

kentucky

title

COAL
MINERS
LIFE

published
by

wendy
an
kattie

card

number

72-86579

18 pages

AUTHOR GREG CORNETT

1

Acknowledgments

We began working together in 1990 when Wendy was developing the Literacy through Photography (LTP) program in the Durham Public Schools. Alex was a graduate student in education at Harvard University, living in Durham, and she was interested in exploring the intersections of art and education, community and culture. She was hired as LTP's first project coordinator, and worked with Wendy to adapt her methods for use by teachers and other educators.

By 1992 we were coteaching a course at Duke University on educational theory and the methodology of LTP to undergraduate students who in turn assisted teachers in the expanding number of LTP schools in Durham. Eventually Alex wrote her doctoral dissertation about the LTP project Black Self/White Self.

For Wendy's work in Canada so many years ago she is indebted to the Quebec Labrador Mission Foundation, which continues to work with children and the environment. Thanks also to Appalshop, the multimedia cooperative that records the life and culture of Appalachia. Her project in India was aided by the Self-Employed Women's Association, a union of home-based workers. For her work in Mexico she owes thanks to Sna Jtz'ibajom, a Mayan writers' cooperative, and to Pequeno Sol and Cuxtitali schools. In South Africa she received help from the Market Photography Workshop, and in Morocco she was helped by the Centre Hassan ll, a cultural institute that encourages young artists. In the Netherlands she received support from the Nederlands Foto Instituut, and the Oscar Romero, Eben Haezzer, and Princess Irene schools. Her work in Saudi Arabia was conducted under the auspices of the House of Photography in Jeddah. The Cleveland Center for Contemporary Art provided support for her work with Central Intermediate School.

Funding and materials for the projects came from many sources, among them: the Polaroid Corporation and Foundation; the Kentucky Arts Commission; the Fulbright commission; the Educational Foundation of America; Kodak Worldwide; the Ricoh Corporation; the Lila Wallace Reader's Digest Fund; the National Endowment for the Arts; the Mondrian Foundation; the United States Information Service; and the Lyndhurst and

MacArthur Foundations, which awarded Wendy fellowships that gave her time to do much of this work.

We would like to thank the Durham, North Carolina, Public Schools and the Center for Documentary Studies at Duke University, which is dedicated to advancing documentary work that combines experience and creativity with education and community life, for supporting our work as artist and teacher. In particular we want to acknowledge the teachers and administrators who have participated in the Literacy through Photography program: Lisa Lord, Denise Friesen, Andrea Bittle, Carolyn Ridout, Robert Hunter, Julia Fairley, Katja Van Brabant-Stevens, Felicia Barnack, Ursula Howard, Synora Fields, Audrey Boykin, Cathy Fine, Linda Dimmick, Bryan Woolard, Linda Strickland, Wanda Grantham, Diane Gore, Belinda Sligh, Bill Wirth, Dietra Arrington, Barbi Bailey-Smith, Katie Becker, Sophia Faison, Anne Bruton, Don Bryson, Cassie Rodriguez, Queen Bass, Brian Fricks, Denise McIntosh, Vanessa Calhoun, Jill Strouhl, Terry Simpson, Marcie Pachino, Malcolm Goff, Lisa Beahm, Linda Summerlin, Tamela Davis, Melanie Middleton, Helen Davidson, Emelia DeCroix, Chas Hood, and Ada Setzer. As always, we must thank our co-conspirators over the years, Alan Teasley from the Durham Public Schools and Iris Tillman Hill from the Center for Documentary Studies, as well as the Literacy through Photography staff, Marta Urquilla, Dave DeVito, Dominique Phillips, Julia Hoggson, Dwayne Dixon, and Katie Hyde. Thanks to Kate Waters and Gigi Dillon for laying the foundation for the LTP archive. We'd also like to thank Ann Thomas, Iris Tillman Hill, and Greg Britz for help with fund-raising over the years.

For Literacy through Photography we received grants from the Andy Warhol Foundation, the Nathan Cummings Foundation, the National Endowment for the Arts, the North Carolina Arts Council, the Surdna Foundation, the General Electric Foundation, the Open Society Institute, and the Triangle Community Foundation for the Qualex Fund.

Alex would like to thank the Z. Smith Reynolds Foundation for their support for her development of a teacher-training program, Regarding Race, in collaboration with the Teaching Fellows program at the University of North Carolina at Chapel Hill. Influenced by Black Self/White Self, Regarding Race uses photography and writing to explore how teachers perceive and experience racial difference in their own lives and teaching. We hope it will become a model for exploring racial and cultural difference in preservice

teacher education to build "cultural competency" in increasingly multiracial classrooms.

For the creation of this book, we'd like to thank Deborah Chasman at Beacon Press; Alexa Dilworth and Iris Tillman Hill at the Center for Documentary Studies; and Katy Homans, the designer. We'd also like to thank Pete Mauney for making the prints; Dwayne Dixon, Katie Hyde, and John Moses for gathering materials; Anika Wilson for her work on the resources section; and Tom McDonough for going over every word.

Our most important goal in this book has been to provide a useful framework for connecting photography to writing and for teaching this process to children. We hope you, our readers, will be inspired, as Alex was in creating *Regarding Race*, to tailor these methods to your own interests and communities.

Wendy Ewald and Alexandra Lightfoot